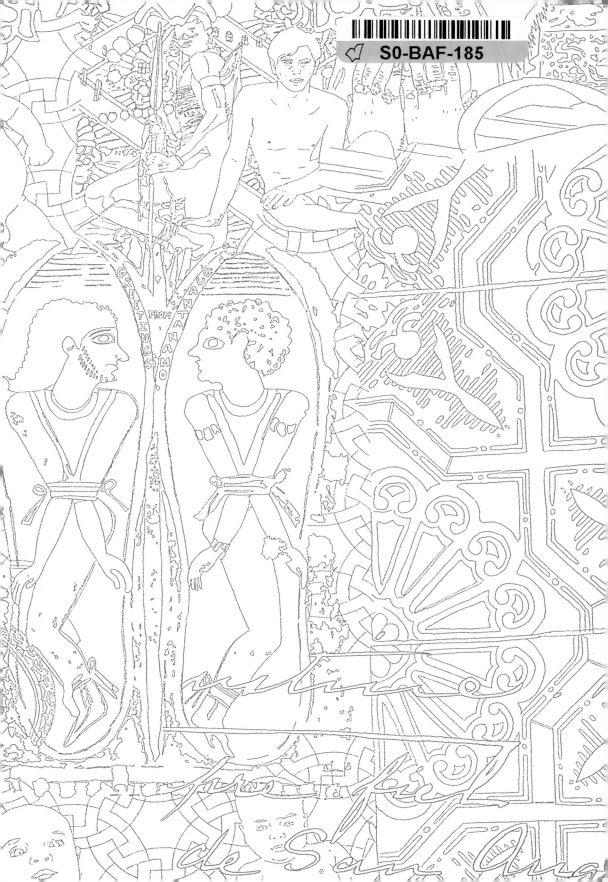

Maurizio Cannavacciuolo

ISABELLA
STEWART GARDNER
MUSEUM

CHARTA

This book is published in conjunction
with the exhibition *TV Dinner*
March 10 – August 15, 2004
at the Isabella Stewart Gardner Museum, Boston

The 2003-2004 Artist-in-Residency program was
made possible, in part, by The Barbara Lee Program
Fund, The Ford Foundation, The Wallace-Reader's
Digest Funds, The Thomas Pappas Charitable
Foundation, The Andy Warhol Foundation for Visual
Arts, The Nimoy Foundation, The National
Endowment for the Arts

Contents

Introduction

Maurizio Cannavacciuolo lived and worked at the Isabella Stewart Gardner Museum as Artist-in-Residence over the course of several weeks in 2003 and 2004. During this time, he brought great spirit to the Museum, and that spirit infected the entire staff. By the time he departed, he had given all of us, and the public too, a very personal gift through his extraordinary works of imagination.

The Gardner's Artist-in-Residence program is now in its twelfth year. In the program, artists of many disciplines—writers, painters, composers, and more—are invited to live and work at the Museum, surrounded by the wonders of its collections, gardens, and architecture. The object of the program is to give unfettered creative time to these guest artists, to respect their processes, and in the end to present the work that results from their time at the Museum. In this way, we wish to support and encourage artists of a range of backgrounds and approaches—some well established in their careers, and others whose names may be unfamiliar to our audiences. Curator Pieranna Cavalchini, who has directed the Artist-in-Residence program since 2000, has broadened the program's scope to include artists from South Africa, India, Italy, Germany and Brazil, as well as the United States.

Cannavacciuolo, though officially from Naples, is something of a world citizen, a true nomad. And with this spirit of wanderlust, during his stay at the Gardner he could be found in the archives, in the galleries, or (just as likely) at the security desk or in the conservation lab. The result of his explorations, executed over the course of nine weeks with the help of four assistants, is a site-specific work titled *TV Dinner*. In subtly beautiful drawings, linked together by his own intuitive stream of consciousness, pictures of modern life are juxtaposed with historical images—taken from the Museum's collection and documents, as well as from the artist's own archive. He presents in this work the dark, disruptive and tawdry aspects of civilization as well as the spiritual and the beautiful, all woven together into a complex web.

Cannavacciuolo is an artist who is sustained by the total experience of life. *TV Dinner* shows us something of his remarkable understanding of that experience.

Anne Hawley
Norma Jean Calderwood Director

Acknowledgments

I first encountered Maurizio Cannavacciuolo's work several years ago, at an exhibition in Milan at Francesca Kaufmann Gallery. I was spellbound by his extraordinarily delicate, intricate, and intense drawings. Obsessive, yes, but full of humor. A giant procession, inching on from room to room. I was struck by the sheer monumentality of such a starkly ephemeral work. Three years later, Cannavacciuolo brought that same remarkable mix to the Isabella Stewart Gardner Museum, with his project *TV Dinner*.

For all of us who participated in some way in Cannavacciuolo's one-month residency at the Museum in 2003, and in the making of this exhibition and artist's publication in 2004 and 2005, the process has been truly inspiring.

As the curator of the exhibition, I would like to thank the many people who helped bring this exhibition and publication to life. First and foremost, of course, the Artist-in-Residence himself, Maurizio Cannavacciuolo, brought to the Museum his remarkable talents and spirit, and has given us a wonderful exhibition and book to remember him by. I am enormously grateful to the Museum's many staff members from all departments—curatorial, conservation, development, the director's office, education, marketing, operations, and security—whose enduring commitment, enthusiasm, expertise, time, and talent guaranteed the success of the residency. A special thanks goes to Tiffany York, who gave her tireless attention to all aspects of Cannavacciuolo's time with us.

I also wish to thank April Gymiski, Anabelle Lee, Lazaro Montano, and Beth Olsen, who assisted Maurizio in his work and created a five-week-long Renaissance workshop at the Museum.

Particular thanks are due to Marcia E. Vetrocq, who very generously contributed a rich and insightful essay to this book. The gifted photographers Stewart Clements and William Howcroft and filmmaker Michael Sheridan have forever captured the magic of Cannavacciuolo's work on film and paper for us. Maurizio worked intensely and harmoniously with the designer Gabriele Nason at Edizioni Charta in Milan to produce this publication; and Diana C. Stoll edited the book's text with patience and care. I am grateful also to Giuseppe Liverani of Edizioni Charta, for recognizing the merits of this project.

None of this would have been possible without the significant support of the endowments established by The Barbara Lee Program Fund, The Ford Foundation, and The Wallace-Reader's Digest Funds. Major support for the Gardner Museum's 2003/2004 Artist-in-Residence program was received from the Thomas Anthony Pappas Charitable Foundation, The Andy Warhol Foundation for Visual Arts, The Nimoy Foundation, and The National Endowment for the Arts. The Gardner Museum is deeply grateful to all of them for their generosity.

Pieranna Cavalchini
Curator of Contemporary Art

Maurizio Cannavacciuolo
Avv. Giovanni de Sanctis, 1995
oil on canvas, 190x110 cm
courtesy Sperone Westwater Gallery, New York

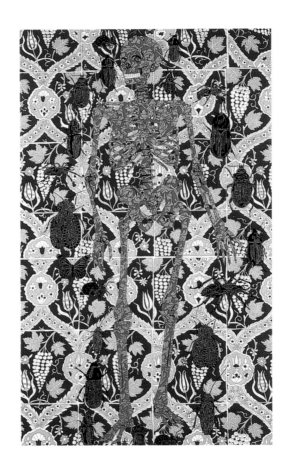

The life-size human skeleton materializes before a background of marine blue, soft aqua, and fresh white tiles. Although the vine-patterned grid presents a flat and continuous field possessing neither depth nor base, the skeleton is plainly standing in space; more precisely, it has assumed the *contrapposto* pose—right foot extended, left hip elevated, arms flexed and at ease—which has signified physical grace and assurance in Western art for well over two thousand years. The volumes of the cranium and rib cage, the stack of vertebrae, the slender femurs, all are readily discernible, but the ivory of bone has been overrun by the flowers and fronds of a gold-on-red brocade. Only those Hollywood-perfect teeth retain their marble gleam, yet even they inject a subtle anomaly, for they resemble the rows of stylized grapes repeated on the tiles. An assortment of enormous insects, rendered in black and white, surrounds the skeleton like the mandorla around a holy figure, while the skeleton—let's speak of it as "he," for the title of this 1995 painting is *Avv. Giovanni de Sanctis* [Giovanni de Sanctis, Attorney]—seems to welcome or even summon them with his outstretched hands.

Avv. Giovanni de Sanctis is both a macabre, fictive "portrait" and a pointedly unpersuasive memento mori whose cautionary iconography of bones, bugs, and sacramental grapes is undermined by the lovely profanity of a decorator's palette and the stubborn vitality of ornament: ceramic fruit and brocade blossoms, after all, will never die. Even the monochrome insects, so various in form, seem less the harbingers of decay than the advance troops of an alternate biological

imperative. The image is exceptionally intricate, and almost ostentatious in the time and labor claimed by its immaculate, lustrous surface. Nevertheless, the painter, Maurizio Cannavacciuolo, calmly recycled the work three years later, re-creating it point by point in one section of the tripartite *Tumori* [Tumors], where it serves as the backdrop for a pair of capering nudes.

Cannavacciuolo is omnivorous in his consumption of visual information, profligate in deploying that data to engineer compositions of breathtaking complexity. His is an art of abundant paradox. Despite the coolly methodical process by which each composition is realized—elements found and photographed, projected, traced, and colored in, often with the aid of assistants—the paintings radiate an obsessive heat. The wider Cannavacciuolo casts his net for imagery, the thicker the air of individual psychology that pervades the work. The liberties he takes with appropriated motifs (altering the original hues of an Edo period textile or a William Morris wallpaper, suspending the lights of a Cairo mosque chandelier in a sea of dentures and creeping nudes) are evidence of an unapologetically contemporary and irreverent temperament. Yet the compositions, with their surface extravagance and abrupt shifts in scale, are likely to inspire comparisons with Mughal miniatures, the relief sculpture of a Hindu temple or Romanesque tympanum, Gothic stained-glass windows—art, in other words, that is anything but the product of the secular here and now.

The first acrylic paintings foretell the mature work only in part. At the beginning of

Maurizio Cannavacciuolo
L'interno del tempio hawaiano sulla laguna, 1981
acrylic on canvas, 210x400 cm
private collection, Naples

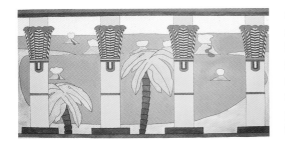

the 1980s, after experimenting with photographs of brief performance events and installations involving mostly readymade or altered objects, Cannavacciuolo launched a series of stripped-down paintings whose flat color, emphatic outlines, and rudimentary spaces evoke comics, Japanese woodcuts, and commercial screen prints. This raw simplicity— essentially the lingua franca of one international variant of Pop painting established by John Wesley, Renato Mambor, Valerio Adami, Patrick Caulfield, and others—would succumb to more decorative urges. But even at the outset, Cannavacciuolo was instituting certain enduring studio practices. He employed projected slides as a rendering tool (Cannavacciuolo candidly admits that he cannot draw), repeated motifs from one work to the next, inserted himself and his friends into compositions, and was willfully imprecise about cultural quotations: Egyptian lotus capitals crown the columns of a fanciful "Hawaiian" temple in a group of paintings from 1981.

Pattern entered the work modestly—a target on the back of a figure's shirt, a spreading fan of geometric sun rays—and was fostered by an increasingly collagelike use of available components, such as nine ornamental masks reproduced in a Chinese theater program or a children's book illustration of a follower of Krishna. The artist singles out a handsome acrylic of 1986, the untitled composition cooked up from widely disparate sources, as the start of what he calls his "complicated" paintings. In this work, a ceremonial portico from the royal palace in Bangkok enframes three Arab gentlemen, one carrying a hawk and two in a boat with a furled sail. The soaring structure's original columns have been replaced by the towers of Antoni Gaudí's Church of the Sagrada Familia in Barcelona, while the towers, in turn, have been adorned with an abstract mosaic from a different building by the Catalan architect.

By this point, Cannavacciuolo was well into the peripatetic life that would take him across Europe and to India, Thailand, Vietnam, Cuba, Bali, the Philippines, Singapore, Hong Kong, Senegal, Kenya, Morocco, and Brazil, and beyond. He has been no less restless in his working habits, setting up studios at different times in Naples (where he was born), Milan, Bologna, Havana, Turin, and Rome. While not strictly travel diaries, the paintings are nourished by those foreign encounters in the form of original photographs taken abroad and secondhand imagery, all of which Cannavacciuolo gathers in an archive of slides. To create *Avv. Giovanni de Sanctis*, for example, the painter assembled slides of Persian tiles he had seen in Lisbon's Gulbenkian Collection, a skeleton from a standard anatomy text, and a brocade printed on gift wrap. Elsewhere, Havana is recalled with the distinctive logo of the local Astoria-brand playing cards as well as with a snapshot of the grandchild of Can-

John Wesley
Turkeys, 1965
acrylic on canvas, 117x132 cm
courtesy Fredricks Freiser Gallery, New York

Maurizio Cannavacciuolo
Untitled, 1986
acrylic on canvas, 150x200 cm
private collection, Mantua

navacciuolo's Cuban landlady. Other works incorporate the leering heads of a dentist's display encountered by the artist in the Chinese quarter of Bangkok, African tribal carvings showcased in a glossy coffee-table book, and a view of the 13th-century vaulted ceiling of Sainte-Chapelle in Paris. Only Gauguin—who used and reused sources preserved in his own trove of photos and drawings recording the art and exotica of ancient Egypt and Greece, Peru, Easter Island, Java, and the Marquesas Islands—anticipates Cannavacciuolo's zeal for flavoring his work with global visual appropriations.

Downplaying the role of intentional expression in his art, Cannavacciuolo confided to one interviewer that his material and iconography are not determined by choice but rather come to him in pre-sleep visions and dreams. Perhaps. Regarding creativity as a form of delirium might help account for the baffling juxtapositions of images and the manifestations of horror vacui, the compulsion to blanket the surface with figures and patterns, as if applying a full body tattoo. But the execution of each work depends on a deliberate and exacting procedure, one made all the more taxing by the artist's switch from acrylic paint to oil in 1988.

Every composition is the outcome of a recombinant process that brooks no improvisation. Slides are projected sequentially (hundreds may be enlisted for the most densely embroidered designs), and each is traced with a fine drafting pencil. For works on canvas, the colors are added one by one, in paint-by-numbers fashion, and then the pencil outlines are painted over in black. In 1994, Can-

navacciuolo began to make entire compositions using a particularly laborious monochrome technique he had previously confined to selected details. To achieve the "negative" effect of these white-line or *a risparmio* works, he projects and traces the slides as usual, and then paints the surface entirely in black, leaving only the most slender reserve of bare canvas along each pencil line. These exposed filaments of white indicate the contours of objects and figures.

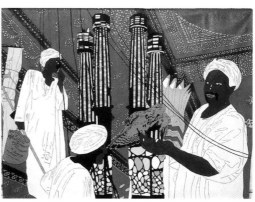

13

Maurizio Cannavacciuolo
Ritratto di gentiluomo in un interno, 1998
oil on canvas, 190x110 cm
courtesy Galleria Cardi, Milan

Polychrome or monochrome, this is a fundamentally graphic operation, in which each projected slide serves as a template for any number of compositions; the application of paint yields a sort of unique hand-colored "print." Cannavacciuolo has employed just one stencil, a homemade cardboard arrow used to generate a few storms of projectiles in his paintings. With that sole exception, the dimensions of the constituent elements are infinitely variable according to the focal length of the projector's lens and its distance

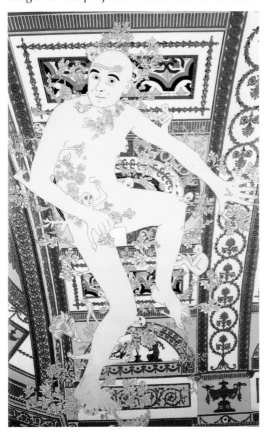

from the working surface; a diminutive beetle in one composition can be aggrandized to horror-movie proportions in another. Context is crucial: placed before the vault of an ornate Neoclassical room in *Ritratto di Gentiluomo in un Interno* [Portrait of a Gentleman in an Interior] (1998), a prancing figure appears to hover like an outsize putto on an 18th-century painted ceiling. Though conventional spatial cues like foreshortening and oblique lines may be embedded in the photographic sources, those sources, like the compositions generated from them, are perfectly, unremittingly flat.

Considered comprehensively, the procedure amounts to a low-tech, man-hour-devouring cousin to digital imaging programs like Quantel Paintbox and Photoshop: replicate any image, scale it up or down, cut, paste, crop, flop, rotate, manipulate the palette. The most complex composition can be encapsulated in a set of instructions and dispatched with the requisite slides to be executed anywhere and (with tolerance for human variation) by other, trusted hands. In this respect, Cannavacciuolo's enterprise weds the variability of digital imaging to the process-oriented conceptual asperity of Sol LeWitt's early wall drawings.

Similarly rooted in Conceptual art's disregard for the coveted object are Cannavacciuolo's own wall drawings, temporary installations he has created since early 2001 in locations that range from commercial galleries in Milan and London to the 18th-century Palazzo Taverna in Rome to, now, the Isabella Stewart Gardner Museum in Boston. Executed in situ, the ephemeral graphite compositions

Fred Tomaselli, *Untitled (Expulsion)*, 2000
leaves, pills, insects, acrylic, photocollage, resin on wood
panel, 213x305 cm
courtesy James Cohan Gallery, New York

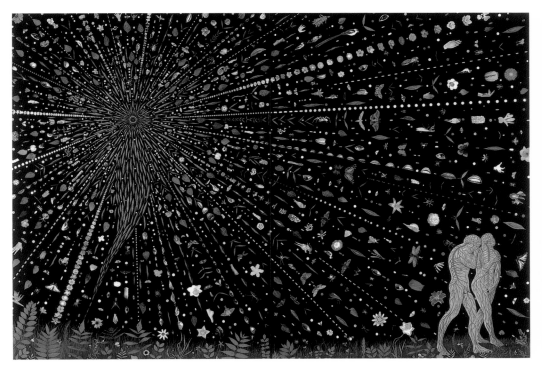

are typically unpainted, beguilingly delicate-looking, and fiercely difficult to read without the figure/ground prompts of color. Cannavacciuolo has made some permanent wall drawings, too, and a few durable compositions have been rendered on sheets of the construction material MDF. But as if to forestall any creeping fetishization of the wall works, in 2003 he completed a drawing on recycled Sheetrock and then smashed it into more than a dozen fragments. The untitled work is displayed in a low heap on the floor, and portions of the drawing are necessarily hidden from view among the overlapping shards. The dimensions of the drawing are "variable."

The destructive gesture of shattering a work is plainly self-destructive as well, for the value of the artist's hours of grueling labor come under attack along with the idea of art as precious property. With similar connotations, though arguably more provocative given its historical roots, another method came into play at the end of 2001. To complete a three-by-six-meter composition for an annual show of posters in Turin, Cannavacciuolo threw paint-filled eggs at his work, thereby retrofitting for artistic purposes what had been the contemptuous missile of the protester, the striker, the anarchist, and the vandal. Since then, he's flung paint eggs at works on canvas and, with good-natured subversiveness, at wall drawings commissioned for Italian

Maurizio Cannavacciuolo
Amore Interrazziale, 2000
oil on canvas, 200x350 cm
courtesy Galleria Cardi, Milan

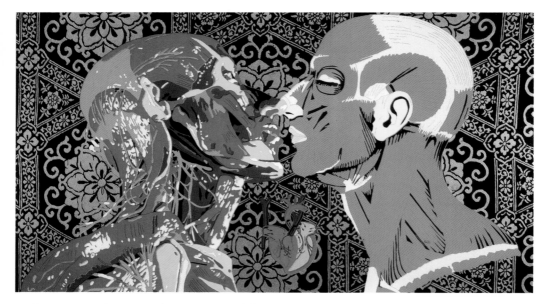

embassies in Tel Aviv and Santiago. And he positively bombarded the tiny exhibition space of Edicola Notte in Rome, hardly more than a little room viewable from the street. Paint smears the window with scatological fury, and through it can be seen, among the branching and proliferating motifs on the walls, the cringing figure of the artist.

If Cannavacciuolo's reiterative and some-times ephemeral oeuvre denies the traditional importance of uniqueness and permanence in art, it also insists on an intimacy between the human body and pattern that is equally defi-ant of Western esthetic authority. With few exceptions, art since the Renaissance has observed a strict segregation of the figure and ornament, one that subordinates decoration to the monumentality and coherence of the human form. It's a hierarchization that com-plements the academic valuation of line over

color, holding reason and clarity above desire and indeterminacy. Of course, defying that prohibition is precisely what recommended the juxtaposition of figure and pattern to artists of the avant-garde, who used it to con-vey spiritual intensity (van Gogh), psycholog-ical distress (Vuillard), erotic abandon (Klimt), and languid well-being (Matisse). The puritan-ically inclined formalist abstraction that over-took vanguard art in the 20th century was no less suspicious of pattern's pleasures than the Academy had been. Even when U.S. painters in the Pattern and Decoration movement of the 1970s found new delight in ornamental design, the human body was all but absent from their work.

Only a few contemporary artists challenge that old taboo as energetically as Cannavacci-uolo. There is a kindred love of excess in the sprawling, hyperkinetic paintings of Lari

Maurizio Cannavacciuolo
La Fine di Paquito a Cuba, 1997
oil on canvas, 70x100 cm
courtesy Galleria 1000eventi, Milan

Lucas Samaras
AutoPolaroid, January 1971
gelatin silver transfer print (Polaroid Polapan print) with hand
applied ink, 7.5x9.5 cm
Whitney Museum of American Art, New York

Pittman, which combine cloying emblems of Americana with crude sexual vignettes. More compelling are the formal and iconic similarities between Cannavacciuolo's art and Fred Tomaselli's hypnotically profuse collages of leaves, magazine clippings, and pharmaceuticals. With skeins of pills, streams of birds and tiny body parts, and anatomical renderings, Tomaselli, like Cannavacciuolo, uses pattern and repetition to work from the diminutive detail to the encompassing system. But the ardent, transcendent effect of Tomaselli's compositions and their underlying nostalgia for nature serve to highlight all that is tart and cosmopolitan in Cannavacciuolo's work. And for Tomaselli the human figure—even when he borrows Adam and Eve from Masaccio's *Expulsion* and rearticulates them as biological diagrams—remains a passive participant, while Cannavacciuolo insists on the intrinsic animation of the body, though he subjects it to all sorts of metamorphoses and indignities in an invented realm that is anywhere but Eden.

The cannavacciuolesque body is an entity in flux, sometimes fragmentary or doubled, a body camouflaged, surrounded, invaded, absorbed. There are brazen sex-trade divas, conjoined fetuses, homosexual couples, flayed figures from medical illustrations, and abbreviated indicators of the body such as dental prostheses, displaced phalluses, and severed limbs. More often than not, however, it's the artist's own body. We come to recognize his mild, if sometimes startled-looking face, which on rare occasions contorts in a howl of pain or protest. Compared to the sensual and primitivizing clichés of the masklike self-portraits that recur in the work of

Francesco Clemente, Cannavacciuolo's simplified visage, conveyed with a few sure notations, is devoid of narcissism, a self-deprecating study in forbearance.

With the elastic contour of a Matisse dancer, Cannavacciuolo's compact form assumes various guises and attitudes, flashily clothed or utterly nude, jaunty as a vaudevillian or hapless as the victim of compounded bad luck. When exposed, the artist's body appears to be virtually androgynous, penetrable and generative but not phallic (though the notorious cast of the estimable organ of porn star Jeff Stryker can be seen growing from

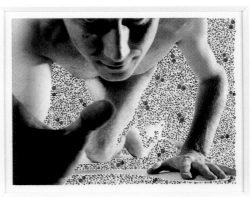

Maurizio Cannavacciuolo
Tumori, 1998
oil on canvas, 200x350 cm
courtesy Asprey Jacques Contemporary Art Exhibitions,
London

Cannavacciuolo's head in some composi-
tions). This reticence pertains even in the
comparatively explicit series of paintings
called "Bilocale" (an Italian term signifying a
two-room flat), which depict homosexual
encounters. Notwithstanding the blatant
activity around crotches, mouths, and bums,
these figures—usually the artist and some-
times a friend—have the genital neutrality of
firing-range silhouettes, and the sexual act
never quite delivers its promised satisfaction.

Dead or alive, Cannavacciuolo seems to
proclaim his helplessness. For the 1998 series
of paintings called "La Fine di Paquito a
Cuba" [The End of Paquito in Cuba], which
exist in small and large formats, he took the
role of a humiliated and murdered Havana
hood. The petty criminal is cradled by a Vespa
in a deft travesty of the Pietà, his red socks a

sign of his trade, his trousers pulled down by
the assassins to expose absurdly tender-look-
ing elephant-print underwear. Within the
smaller versions, nearly invisible against the
background of a Persian carpet, is an array of
hands, numbered according to the letters of
the alphabet, fingers arranged to form the cor-
responding sign in the manual language of the
deaf, and spelling out the double insult *cor-
nuto e ruffiano*: "cuckold and pimp."

In *Tumori*, Cannavacciuolo sprouts dozens
of miniature fragments of his own head and
limbs, a not-so-veiled equation of creativity
with rampant metastases. Tucked into the foli-
ate pattern in the right section of *Tumori*, just
behind the Christmas ornaments and the
woodpecker skeleton fortified with extra
bones, are sixteen hands that spell out *Sono
un poveraccio*—"I'm a loser." An apogee of

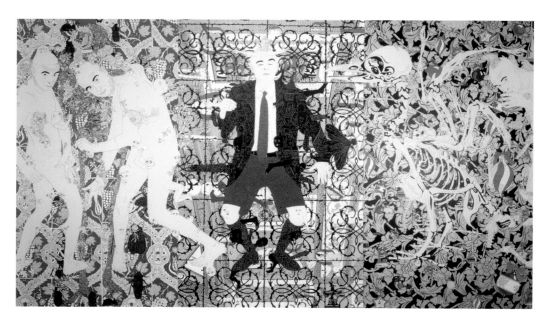

Maurizio Cannavacciuolo
Portabandiera, 1996
oil on canvas, 200x200 cm
courtesy Galleria Sperone, Rome

self-abasement is reached in the monumental *Portabandiera* [Standard-bearer] of 1996, a two-meter-square canvas in whose center kneels the artist on all fours. He is nearly concealed by colorful tiles and grille work, and by the pattern that fills his contour like a superhero's skin-tight suit. A sizeable tarantula occupies his open mouth, the flag of Italy is stuck in his ass, and clean blue capital letters announce "MAURIZIO CANNAVACCIUOLO È UN RICCHIONE DI MERDA"—"Maurizio Cannavacciuolo is a shitty fag".

Yet for all these declarations of powerlessness and abjection, it is precisely in the presentation of himself that Cannavacciuolo exercises the greatest agency. Although he occasionally resorts to using another model, the artist's own body is the one significant pictorial element that is neither found nor appropriated, but is wholly posed, staged before a camera. Cannavacciuolo appears in his work in what is essentially the residue of a private performance. This use of documented actions echoes his earliest creative efforts and also brings to mind the "AutoPolaroids" (1969-71) of Lucas Samaras, which show the nude artist crouching, reclining, crawling in a measureless environment of ornamental dots and lines painted on the photographic surface. But the contrast between the intentions of the two is fundamental. Cannavacciuolo indulges in none of Samaras's self-absorption and exhibitionism, preferring instead to assume a versatile dramatic persona, sometimes the provocateur and sometimes the whipping boy, antic, long-suffering, plucky, vulgar: *un'ometto*—just a little guy—as he disarmingly describes himself.

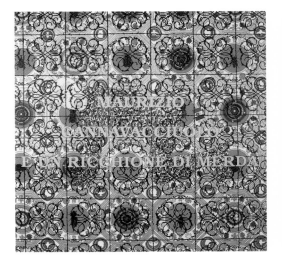

With an encyclopedic repository of cultural signs at his command, Cannavacciuolo nonetheless proceeds with the resourcefulness of the underdog—sly, a touch self-mocking, indirect, irrepressible. His paintings, for all their uncommon splendor, are the fruit of scavenged parts and punishing work. The uninhibited mixing of visual citations breaches borders, time periods, and social classes, but Cannavacciuolo's art, far from being an assertion of postmodern arrogance, is a wise man's exercise in acceptance: nomadic freedom and studio toil, beauty and brutality, life and death, the sublime and the sordid, the garden and the serpent.

Rome, 1993, Gion Enzo Sperone Gallery, 5 PAINTINGS t

DENSE PHOTOGRAM—

oil o
190

ea

to s

caos

ntly aligned next to each other,
canvas
110 cm each.

New York, 1996,

Sperone Westwater Gallery,

THEY turn into 12 paintings,

h aligned ~~xxx~~ with a FEW inches

ore. THE CONTROLLED

grows...

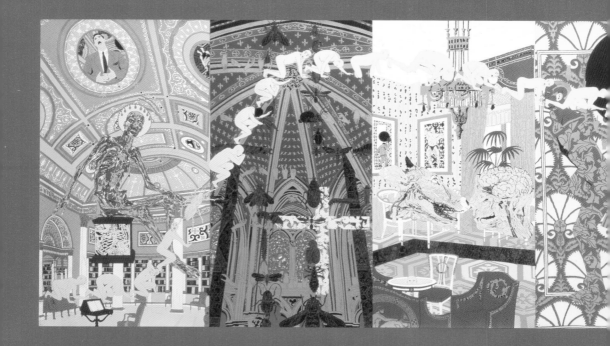

← Processione. (Procession), 215 x 78

the desire for ${ }{}$ ⌇⌇⌇

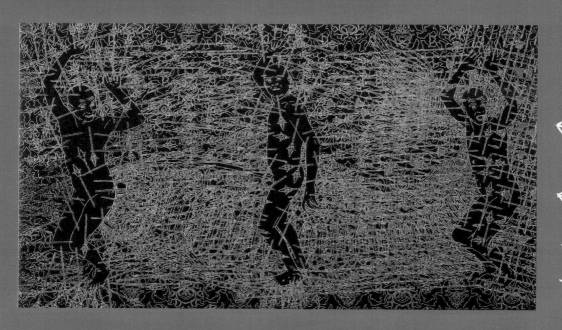

co
of
tr
TH

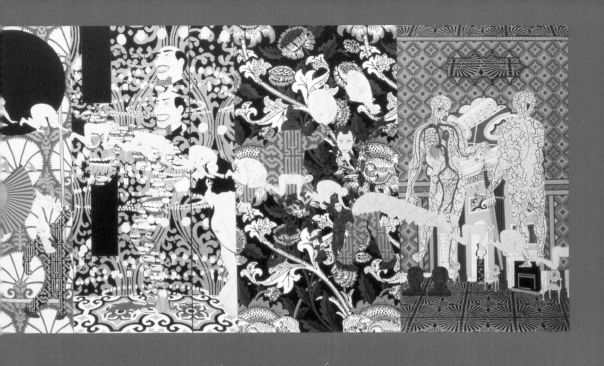

cm, MAKES EVIDENT

...LEXITY in 1998.

r orgy recedes and I use only

BLACK PAINT on canvas

leave UNPAINTED WHITE LINES.

guerrieri (THREE WARRIORS) in 2000 at

CARDI gallery, Milan.

IN 2001 I turn to pencil. ~~Musa~~
~~Musa~~ SENZA TITOLO (Untitled) at the
FRANCO Noero Gallery, Turin.
Sheets of paper
fill the

ENTIRE
WALL
(307 × 473 cm) with library
ladder
 → AT THE
 SAME TIME
 FRANCESCA →
 KAUFMANN hands
 me the ⊙⎓⎓⎓ KEYS to her
gallery (Milan) and goes off on
CHRISTMAS vacation. when she gets BACK →
all the WALLS are finely DRAWN.
Pieranna Cavalchini CATCHES UP with me

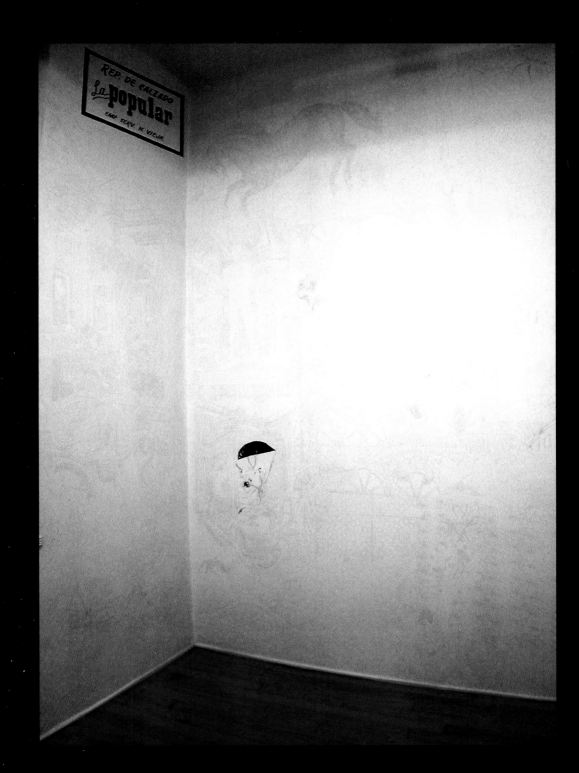

In 2002 Graniella DECORATE the LONARDI BUONTEMPO CEILING of t

A ~~Kew~~ FEW MONTHS later ACHILLE
BONITO OLIVA
invites me in a
GROUP SHOW
Le Opere e i Giorni.
MY WORK is barely
VISIBLE.
Pencil wall
drawing

TITLE

L'UNO
E
TRINO
(The One
is the
TRINITY)

PHOTOGRAPHERS
GO NUTS

UPON Pieranne's suggestion, asks me to
ARCHIVES at Incontri Internazionali d'Arte at PALAZZO
TAVERNA, ROME. Pencil with paint TO
underscore THE { C R A C K S }
on the WALLS.

LONDON
2003
I use a permanent ink felt pen
to DRAW the ceiling of the
East Bar of SKETCH .

a swinging
night spot. TITLE: 37
Each Weapon is a Masterpiece.

THREE SMALL

The Italian Embassy in Tel AVIV (GRAZIELLA MAKES IT HAPPEN)

Ambassador GIULIO TERZI DI SANTAGATA.

PERMANENT

PAINT-FILLED

SPOTS ON A CURTAIN (detail view)

Sprovieri Gallery London. Lines of BLACK PAINT.
Black stripped down FIGURES (a risparmio!
SPLATTERED WITH
PAINT-FILLED-EGGS.

Senza Titolo (UNTITLED
200 x 350 cm.

invites me to ⟨DECORATE⟩ THEIR
MEETING
ROOM.
INK FELT PEN AND OIL
PAINT,
EGGS THROWN ON WALLS.

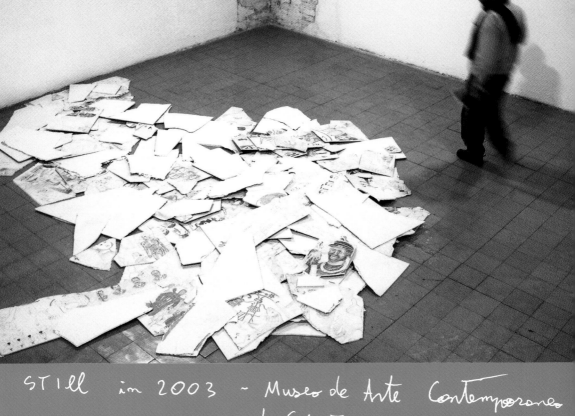

STILL im 2003 ~ Museo de Arte Contemporaneo
de SANTIAGO, CHILE.

A DRAWING ON SHEETROCK, later
SMASHED, with 2 PENCIL TECHniques.
12 assistants _ Title: DESECHO = left overs
NEXT OFF TO Boston for ⋮⋮ DINNER.
HAVE fun with the following PAGES!

TV Dinner, entrance view of the Special Exhibitions gallery
Isabella Stewart Gardner Museum, Boston

Maurizio Cannavacciuolo and *TV Dinner*

Pieranna Cavalchini

The Isabella Stewart Gardner Museum's collection is a very stable one, as mandated by Mrs. Gardner's will, which stipulates that nothing may be moved within the galleries, and that nothing may be added to or removed from the Museum's holdings. Indeed, the Museum's contents and arrangements may be considered as a kind of single work of art. And yet, within this collection that is so permanent and unmoving, the Special Exhibitions room is a "free space," a kind of *sancta sanctorum* that serves as a place where an artist's vision can begin, and grow, and take form. It is a room in which things can change, and do, where things can be created, and are.

The Special Exhibitions gallery is small room at the back of the Museum, with low ceilings, difficult lighting, and an irregular shape. Nonetheless, over the past nine years this room has been the site of many extraordinary shows and individual works. The exhibitions have covered a span of centuries and cultures. Some have been engaged in historical analysis, academic interpretation, and new scholarship, while others have offered contemporary artists the opportunity to reinterpret objects in the Gardner's collection or to respond to the Museum in some new way.

While the segue from one exhibition to the next in this gallery has generally been more or less *extempore*, the room recently housed back-to-back shows featuring works by Italian artists—separated in history by centuries, but nonetheless related by more than mere nationality: Benvenuto Cellini and Maurizio Cannavacciuolo.

Brief takes on these:

Cellini: Picture two Renaissance bronze busts, created by the same hand, facing one another across the floor. Two powerful men, two Florentine rivals: Bindo Altoviti and Cosimo de' Medici, a Renaissance banker and a princely warrior, gazing at each other slightly askance. With these two extraordinary portraits, the glorious vitality of the work of Cellini—one of the greatest Italian Renaissance sculptors—was made very clear in the Museum's Special Exhibitions room.[1]

Cannavacciuolo: Now picture a delicate and time-bound wall drawing by another Italian artist, a contemporary Neapolitan but truly a "citizen of the world," who, as Artist-in-Residence at the Museum, was invited to create a project several months later in that same setting. Although ephemeral, Cannavacciuolo's work, too, is infused with electrifying energy and not easily forgotten.

What could be more challenging and invigorating to an artist than to be asked to put together a show in the recent shadow of a Renaissance master? And in a building that abounds with specters of the remarkable talents and personalities of the past, the spirits of the artists in the surrounding rooms, including (to name just some of the Italians) Giotto, Piero della Francesca, Cosmè Tura, Giuliano da Rimini, Fra Angelico, Simone Martini, Raphael, as well as Cellini.

Perhaps most important, however, is the spirit of our own patron saint, the founder of this collection, Isabella Stewart Gardner. She was a woman of singular vision and momentum, who traveled the world on a journey of discovery and enlightenment. She was, indeed, a relentless traveler—when she was young, discovering with her husband the great

collections of Europe, selectively acquiring many treasures during the course of their journeys, and in later years exploring the cultures and architectural environments of more distant lands. With her insatiably inquisitive mind, she traveled through Cuba and Europe and Asia and across the United States, watching and listening to everything, absorbing it all, immersing herself in ideas and concepts from books and friends, establishing lasting epistolary relationships throughout the world—all the while maintaining her view to creating her Fenway Court with her precious acquisitions. She was assembling a great collage of sorts, with the world as her inspiration.

In his extraordinary wall drawing *TV Dinner*, our contemporary protagonist, Cannavacciuolo, followed Mrs. Gardner's example in his way—drawing together myriad ostensibly unrelated elements from the past, the present, the personal, and the universal, using as his "solder" a mordant wit, an architect's attention to detail, and an anthropologist's obsession with inventory. "Mrs. Isabella Stewart Gardner took me by the hand and led me through her Museum, which is a kind of universe suspended in time," Cannavacciuolo says. "She smiles graciously, with irony and melancholy, from all the nooks and crannies. In my way I have tried to imitate her smile."

Gardner Travel Scrapbook (1876–1886)
National Museum, Stockholm, Sweden
Image selected by Maurizio Cannavacciuolo for *TV Dinner*

Gardner Travel Scrapbook (1876–1886)
Jacksonville by boat
Image selected by Maurizio Cannavacciuolo for *TV Dinner*

Also like Mrs. Gardner, Cannavacciuolo is something of a nomad: he lives in perpetual motion. But he is first and foremost a citizen of Naples, the ancient southern Italian city that has been a bedrock for artists—from Caravaggio to Joseph Beuys, from Luca Giordano to Andy Warhol—over the course of many centuries. Rich in historically diverse layers of culture, Naples has given this artist multiple fields of reference and inspired his stylistic eclecticism. And as an inveterate traveler, Cannavacciuolo is deeply aware of the cultural dichotomies of North and South, East and West. His extensive journeys have led him to study, live, and explore the Far East, where he has spent much time particularly in India and Thailand. He is a cosmopolitan, transcultural soul—part painter, part architect, part philosopher, part writer. He is a critical observer who is blessed with an acute sense of the absurd.

Cannavacciuolo began his residency at the Isabella Stewart Gardner Museum in the fall of 2003, staying for a month in the old carriage house behind the Museum. During the days, he wandered through the galleries looking at the collection and the building, exploring the conservation labs and spending time in the Special Exhibitions room (where Cellini's busts and other major works of the Renaissance were at the time on view), making plans and thinking about his own project. He also spent many hours in the Museum's archives, exploring Mrs. Gardner's collection of rare books, as well as her personal travel scrapbooks and guest books. Perusing these volumes in his seemingly casual way, Cannavacciuolo brought his focus to Mrs. Gardner's Cuba-Mexico-Denmark travel scrapbook. From this book, he selected and plucked out images for possible use in his own piece. He worked like an astronomer, searching the random stars for patterns in the chaos of the universe. (Curator: "Which images do you want?" Artist: "Which ones? … As many as possible. You decide.")

Items of specific interest were collected, copied, and set aside. Some three hundred images in the form of slides were finally gathered—like threads of many different hues—for Cannavacciuolo to work with. With these he would later compose his wall drawing *TV Dinner*, a vast, elaborate, Balzacian tapestry that combines countless visual elements, mixes

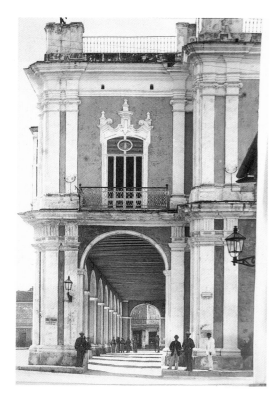

drawn from the artist's experiences at the Gardner and from imagery he himself has created and amassed throughout many years—were projected and traced by hand onto the walls: a slow and painstaking process, during which the Special Exhibitions gallery was as calm and focused as a Zen meditation chamber.

TV Dinner was a synthesis of visual materials, historic and modern. It referenced a wide range of sources, from fine art to popular culture. It included images of Cannavacciuolo's own paintings from the 1980s and '90s as well as pictures of everyday life and culture that he has been collecting for years. The artist brought together photographs from his native Italy and from his travels in Cuba, advertisements, and comic strips by Stan Lee, as well as images obtained from the Gardner's archives. In the resulting multilayered drawing, each visual element leads you to the next in a dazzling procession. It is a brilliant juggling act of emotion and beauty and cultural issues both trivial and weighty. The title itself is unabashedly ironic: Cannavacciuolo explains: "A TV dinner in front of a TV set can fill your stomach and your brain without leaving anything good in either case. With this exhibition, I am trying to do exactly the opposite."

With *TV Dinner*, the Special Exhibitions space became a kind of lively, even theatrical, metaphor for the world at large. The work was colorful, illustrative, narrative, its component images presented in a witty and often light-hearted way. But despite the work's apparent playfulness, the images in *TV Dinner* ran a gamut from light to dark—from slapstick to scathing social commentary. Cannavacciuolo is an artful builder of connections; here he

metaphors, and yet ultimately reveals harmony in the midst of disorder and proves once again that the greatest works of the imagination have an infinite capacity to communicate.

Cannavacciuolo returned to the Museum in February 2004 and spent five weeks creating *TV Dinner* in the Special Exhibitions gallery. Working methodically every day, Cannavacciuolo and four assistants (April Gymiski, Annabelle Lee, Lazaro Montano, and Beth Olsen) created this site-specific piece literally before the eyes of Museum visitors, who were able to view the process through a built-in gallery window. Slides of selected images—

Gardner Travel Scarpbook (1876–1886)
Plants and views of St. Augustine, Florida
Image selected by Maurizio Cannavacciuolo for *TV Dinner*

demonstrated how the tactical placement of images and a shifting context can invoke laughter or contemplation, fear or horror. His points are subtle and yet biting. In one scene, we saw a seated child, resting her head on a kitchen table. She was surrounded by the requisite pots and pans, but also by handguns. Elsewhere, we found an ad culled from a gun magazine, proclaiming, "Korth. Precision in steel. Each weapon is a masterpiece." In still another spot, an image of a Native American woman (taken from the Mexican chapter of one of Mrs. Gardner's travel scrapbooks) was juxtaposed with another gun. Cannavacciuolo's accompanying text had her begging forgiveness: "I'm sorry Senor Rio!" Further along, the Cuban State House (a replica of the U.S. White House) was sketched with a toy grenade near its dome. That dome, in another image, had a baby at its center. Elsewhere, two Egyptian slaves faced one another at one end of a pharaoh's sarcophagus, and sent greetings from Guantánamo, Cuba—the site of the infamous U.S. prison facility in which hundreds of detainees have been held during America's "global war on terror." (What could be more symbolic of perpetual death and imprisonment than being locked in the limbo of a pharaoh's tomb?)

Cannavacciuolo's vision is truly all-embracing. He brings the viewer into his own life, his private world, with images from his childhood fears and fascinations, such as gigantic insects—cockroaches, flies—that scaled the walls of the gallery, some of them shown soaring along the waters of the Canal Grande in Venice toward the Palazzo Barbaro, while others stuck helplessly to flypaper. He included passages of decorative patterns from many sources. He juxtaposed images from diverse religious contexts—in one spot, a Buddhist monk was depicted sitting with an optician, who checks his eyesight beside the holy Mosque of Jerusalem. Cannavacciuolo uses images from this wide variety of sources as tentative probes, as means of insight. He does not approach his work with a fixed idea about the ultimate product; rather, like a jazz musician improvising, he understands that his project is mutable, that the work may be modified at whim—his own, or sometimes that of his assistants.

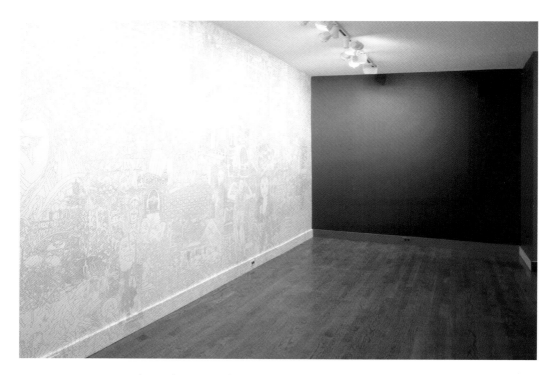

His team spent long hours and many weeks tracing the images projected on the walls; five slide projectors were used in the process. Pencils in hand, standing on ladders, they covered 410 square feet of wall surface. In a whirlwind of artistic energy, working simultaneously at five locations of the drawing, Cannavacciuolo rearranged the slide projectors (and thus the images on the walls) without apparent design, without any preparatory sketch. One by one, images were traced. A giant puzzle began to come together, with layer upon layer of interconnected stories.

And with this extraordinary ability to shift his footing, Cannavacciuolo switched approach from drawing to drawing within *TV Dinner*: context, size, perspective, and subject matter are all dizzyingly inconstant. He seemed to view the three hundred slides and images simply as component parts to be used and combined. Like a filmmaker, he artfully interspliced long shots, close ups, zooms, pans, details; like an orchestra conductor, he combined tempos, dynamics, instruments, so that the cacophony of source material achieved, in the end, a compositional coherence.

Cannavacciuolo is fascinated by how a visitor behaves in a given environment, and how a space can affect one's self-awareness. He calls into question our perception of reality, which is subject to review as our vision

changes. As viewers entered the Special Exhibitions room to see *TV Dinner*, they were confronted with two walls: one painted a rich red, the other yellow. With this simple but forceful strategy, the artist created a boundary between the Museum proper and the exhibition space, defining the Special Exhibitions room as his own, and providing an incongruously bold contrast to the subtle drawing itself, which was seen on the opposing white walls. In his interview in the introductory brochure text the artist warned: "You should not trust the bright, safe primary colors that can be seen from outside the gallery—instead, you should step inside the room and be ready to spend a lot of energy in discovering the content of the two white walls. There will be an entire universe under your eyes as long as you are willing to pick it up. This is a *machine à penser*." Viewers who accepted this challenge looked beyond the colored walls, and as their eyes grew accustomed to the lighting, his delicate web of images slowly came into focus. Untangling the thread, finding a satisfying narrative, became each viewer's personal adventure.

Much if not all art is an intimate collaboration between artist and viewer. In Cannavacciuolo's case, the artist wants his audience to assemble their own ultimate understanding of the work from these images. He seeks to draw us into an exchange, to slow us down, to start us on the process of making our own storyboard, so that we may find our own insights here. Much like Mrs. Gardner herself, Cannavacciuolo is driven to stimulate, to *saturate* the visual senses of the audience. The viewer is the ultimate interpreter, and Cannavacciuolo's *TV Dinner* privileges the very human act of selecting how and what to interpret. Those who chose to engage with this work were intrigued, sometimes puzzled, and—as the artist intended—provoked to bring their own experience and sensibilities into play, to enter into the creative process itself.

1. Cellini's two busts were among the works featured in the exhibition "Raphael, Cellini, and a Renaissance Banker, the Patronage of Bindo Altoviti" (October 8, 2003–January 12, 2004), which preceded Cannavacciuolo's show in the Museum's Special Exhibitions room.
2. "Gondola Days: Isabella Stewart Gardner and the Palazzo Barbaro Circle" was concurrently on view on the Museum's fourth floor (April 21–August 15, 2004).

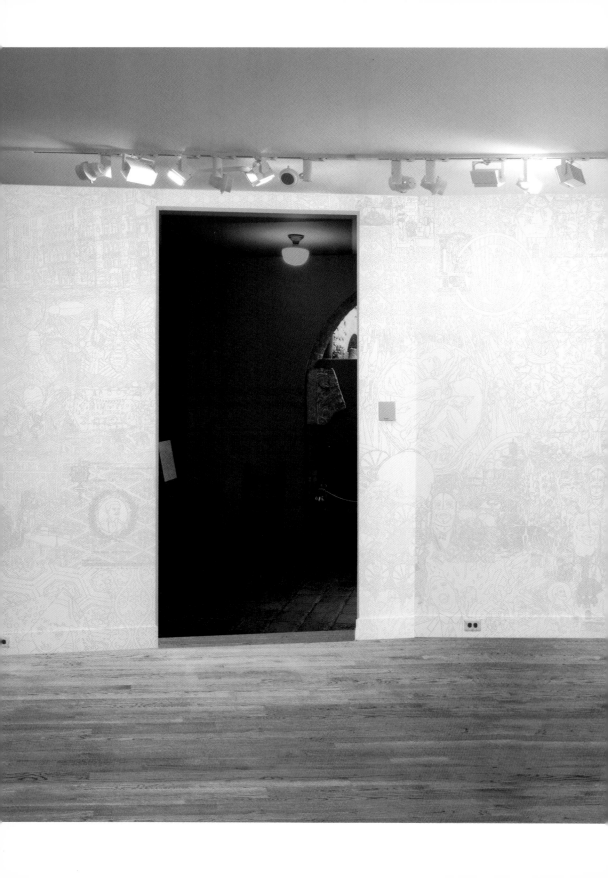

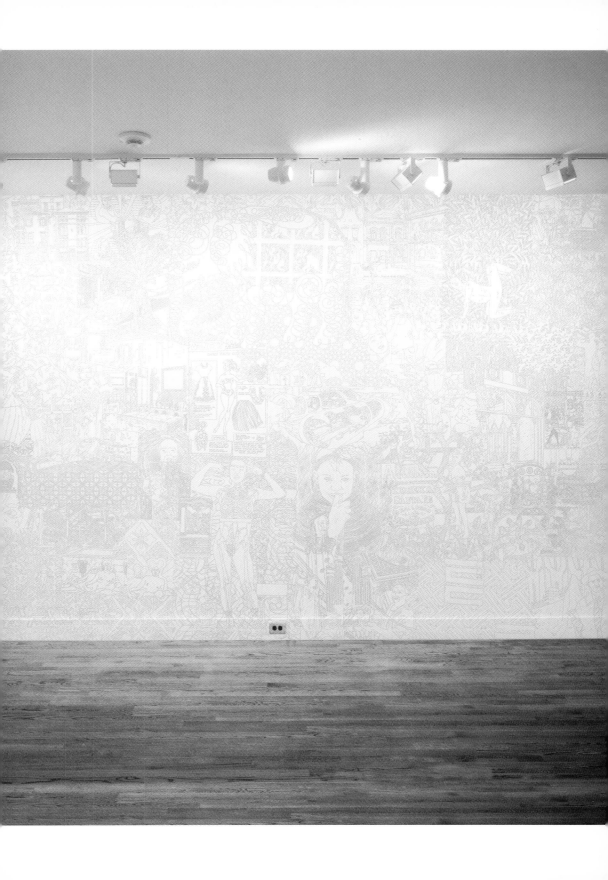

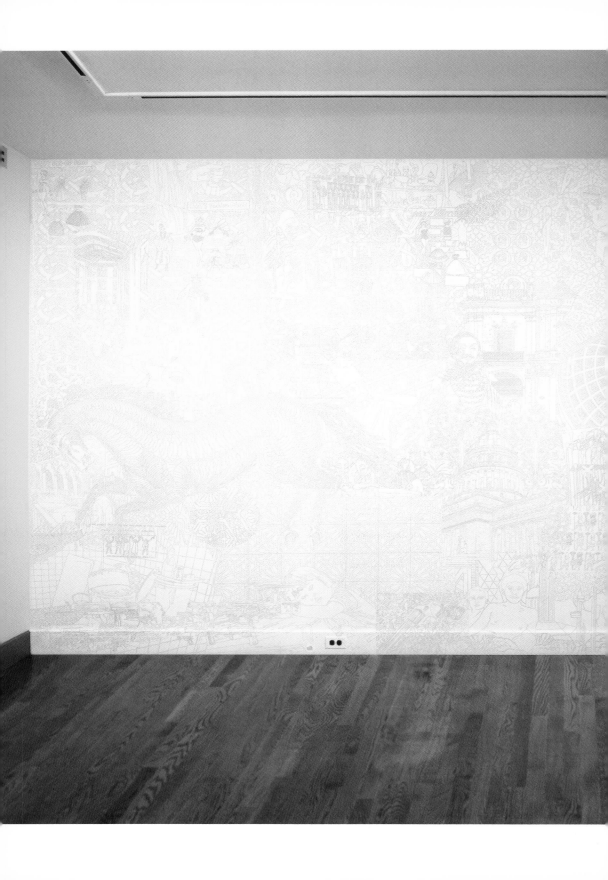

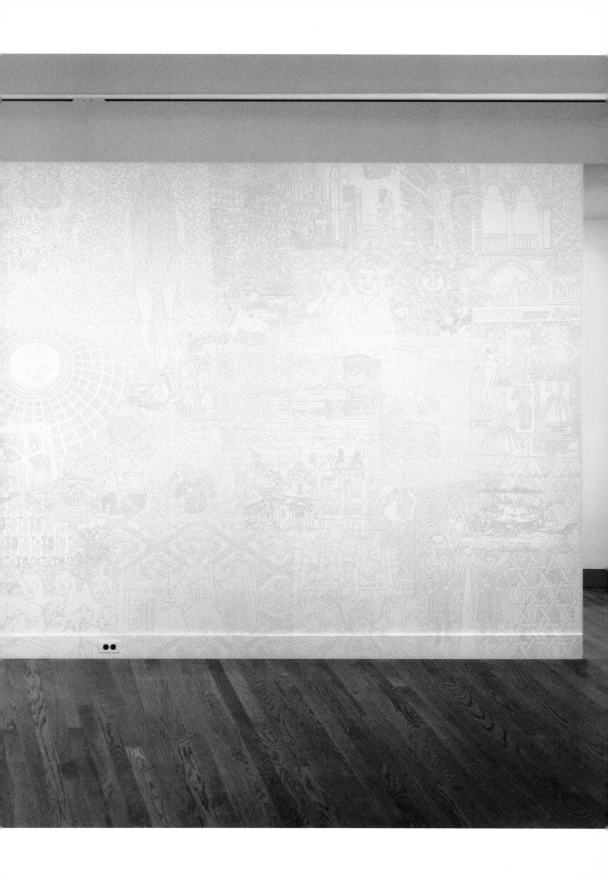

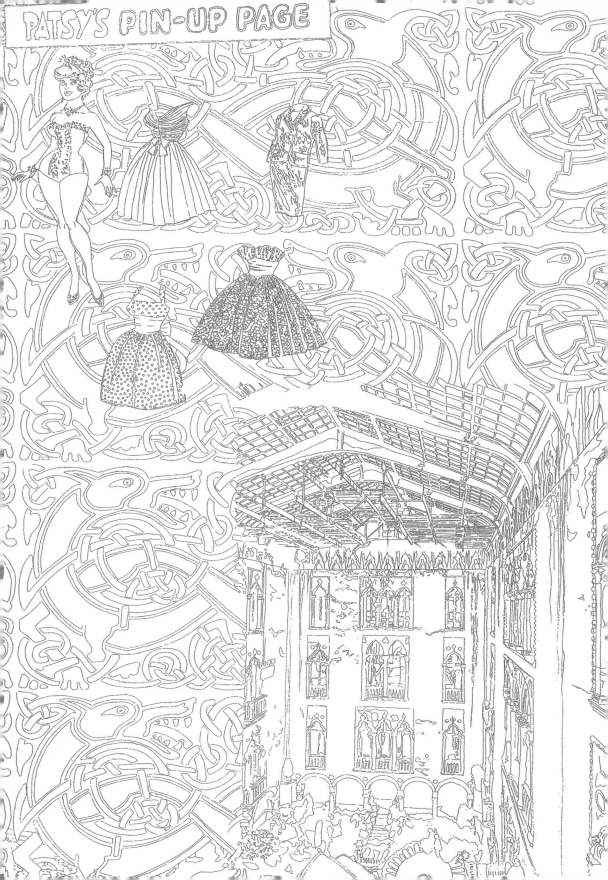

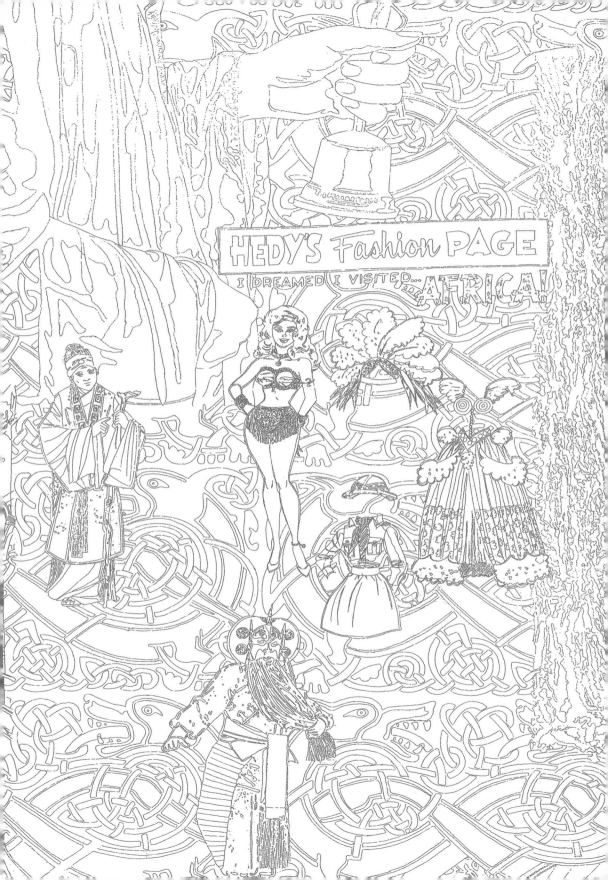

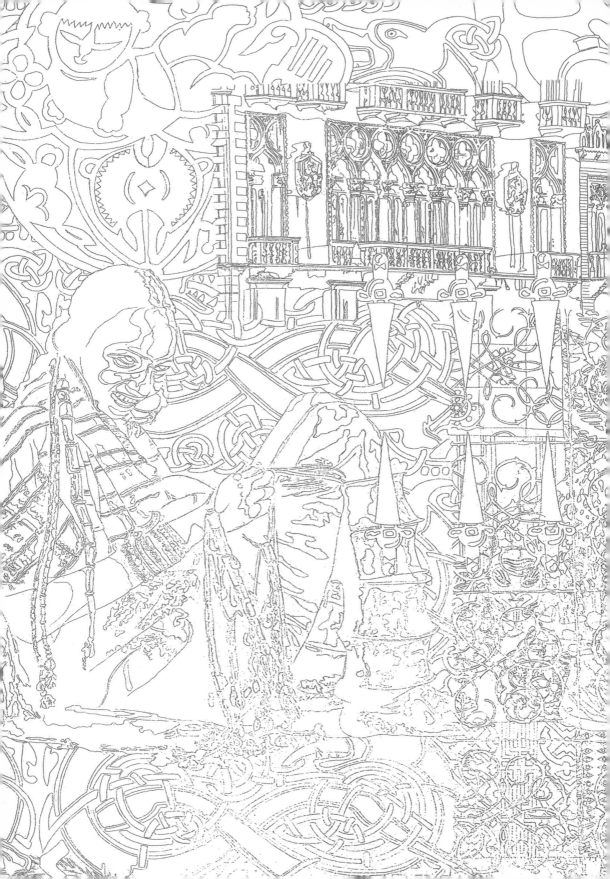

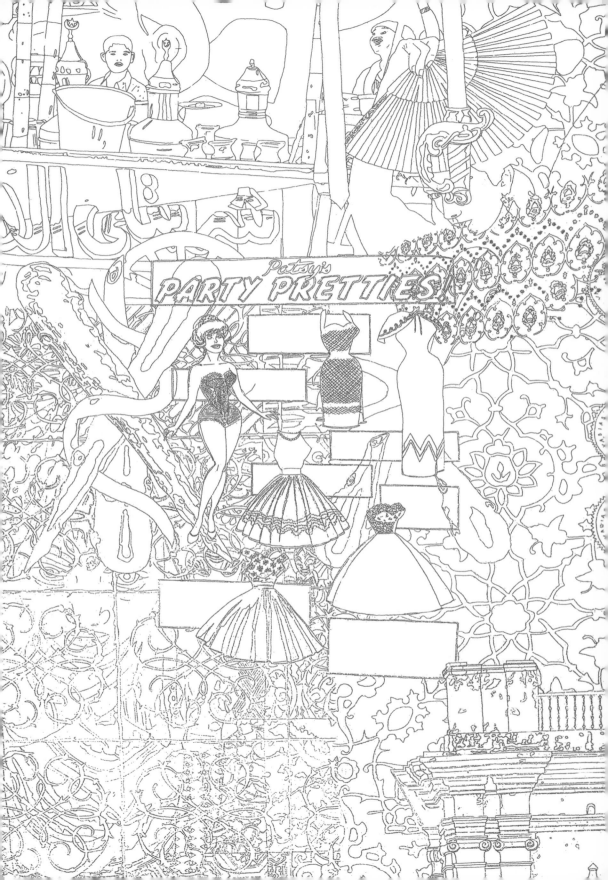

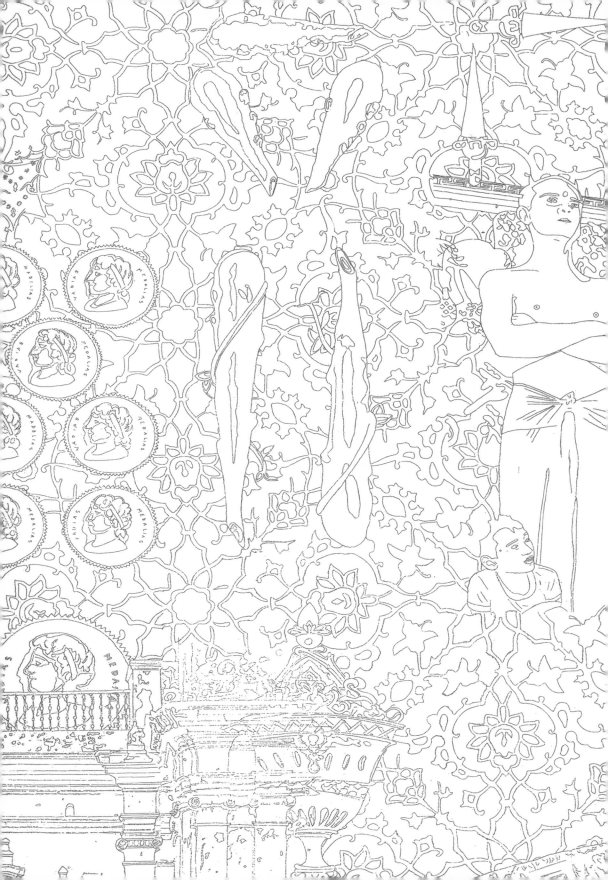

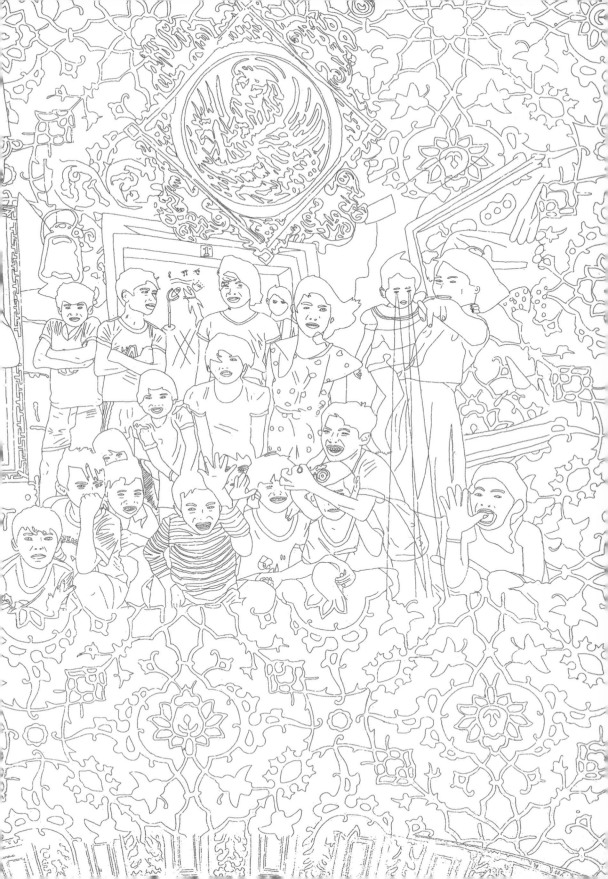

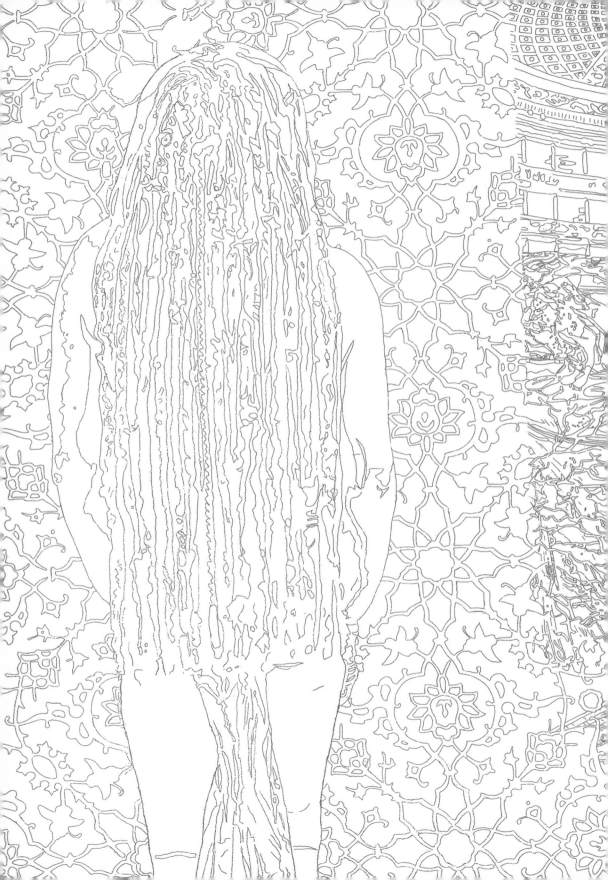

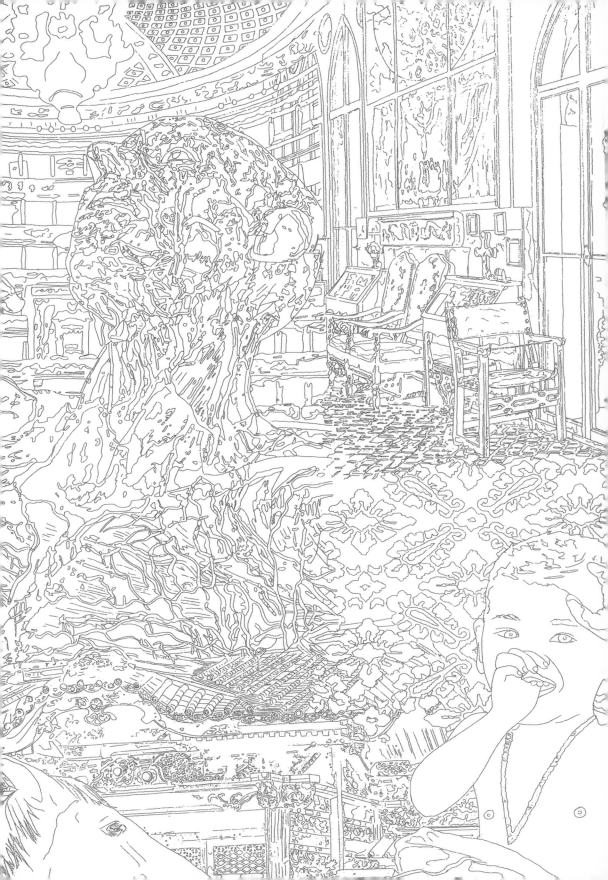

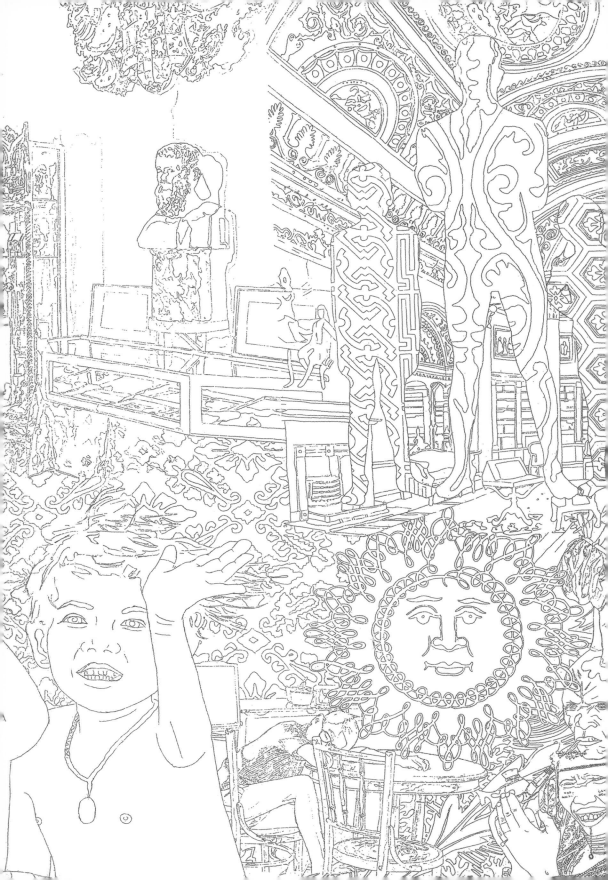

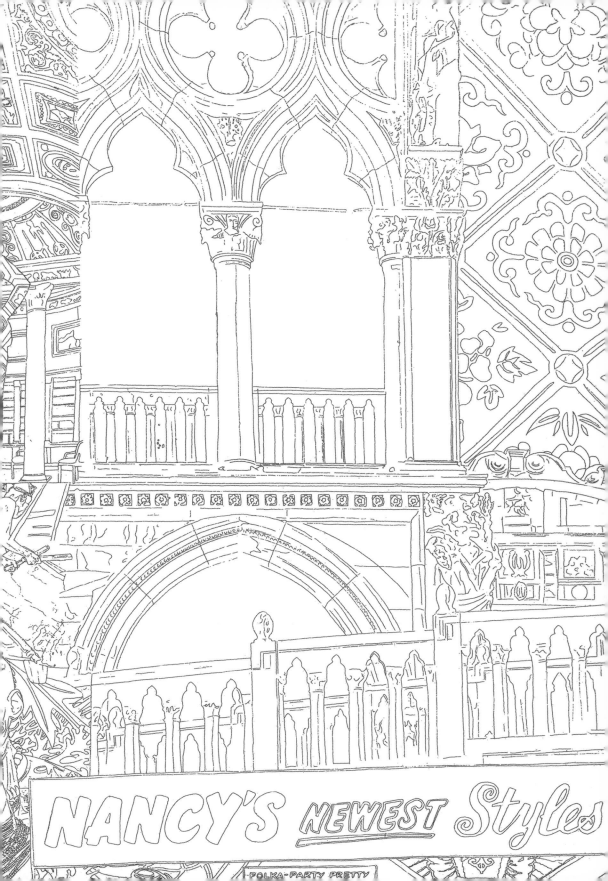

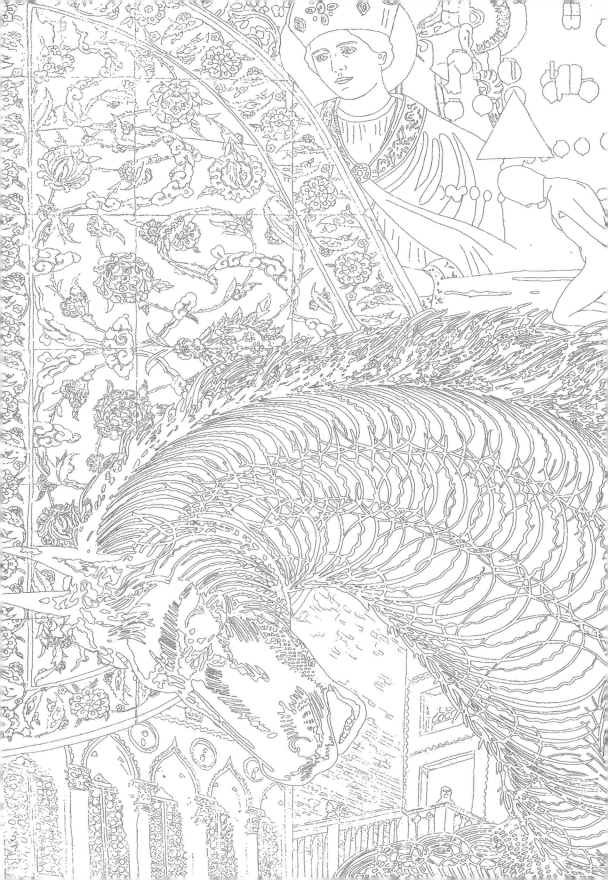

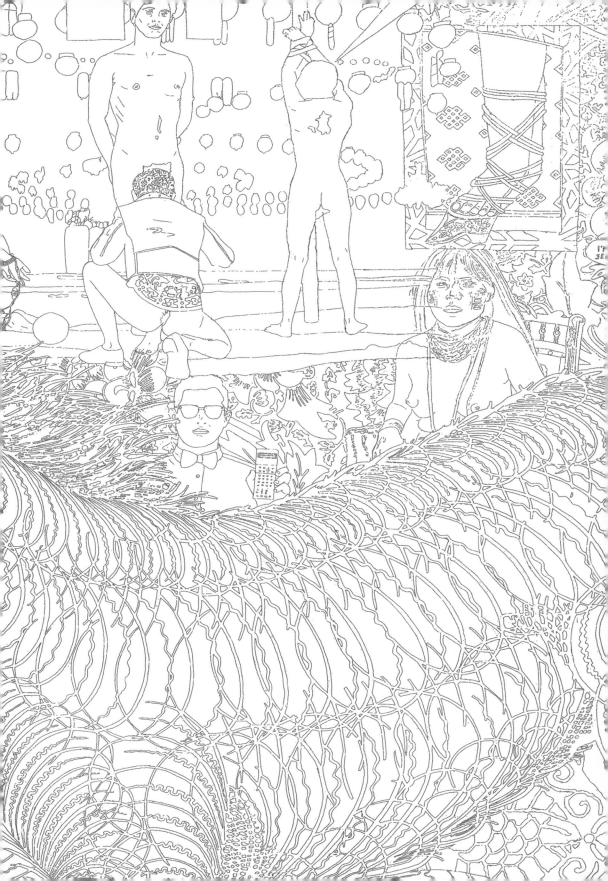

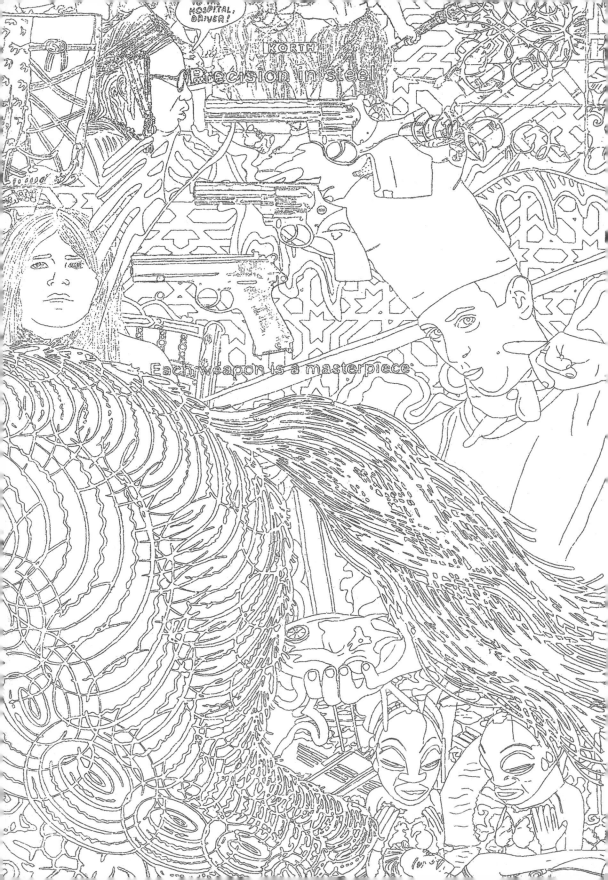

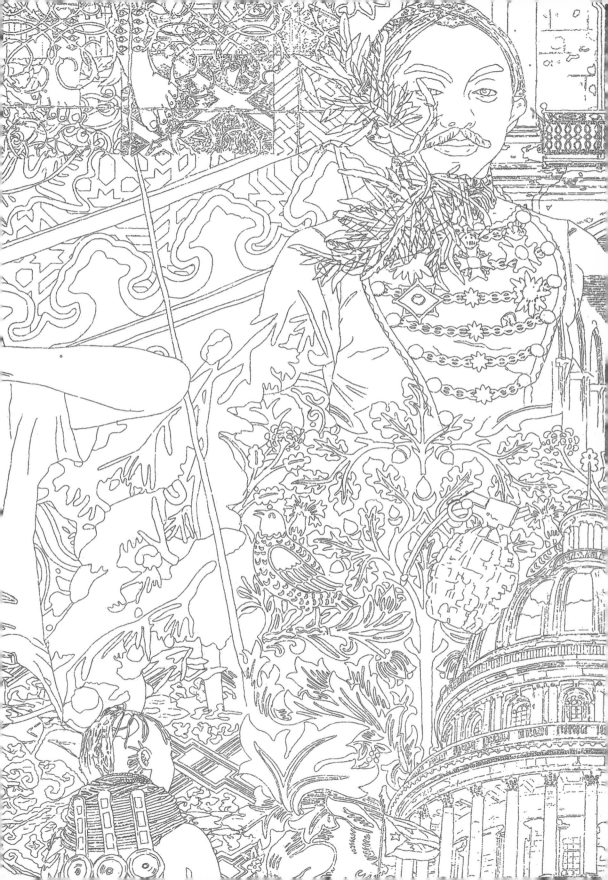

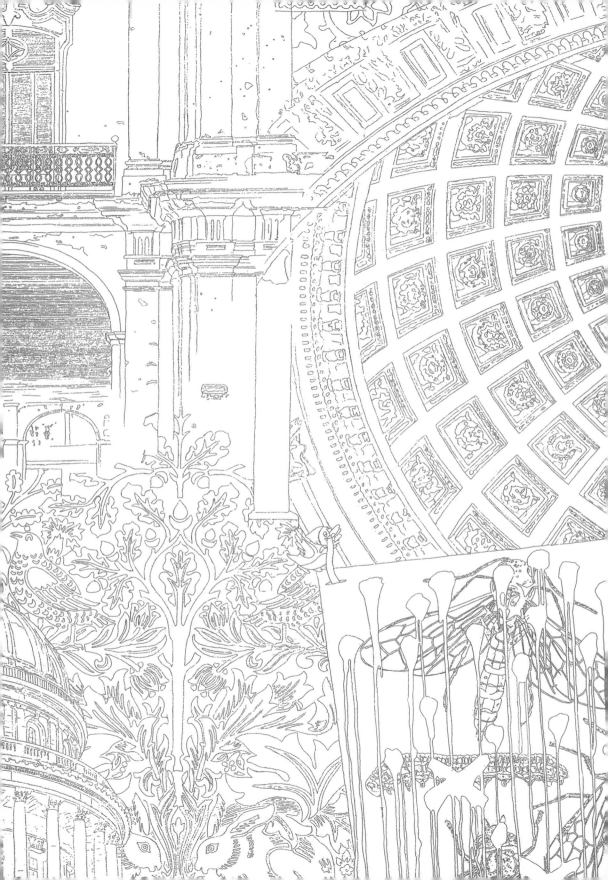

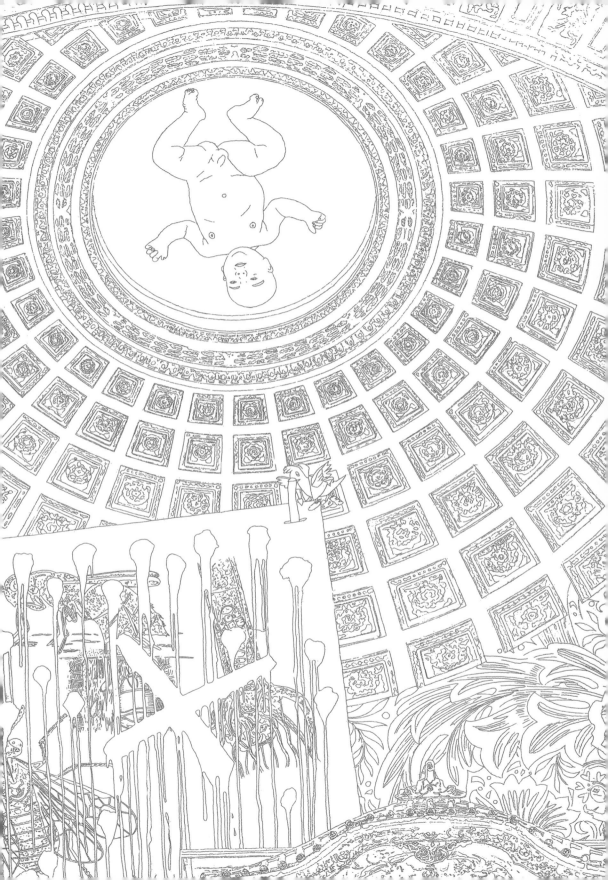

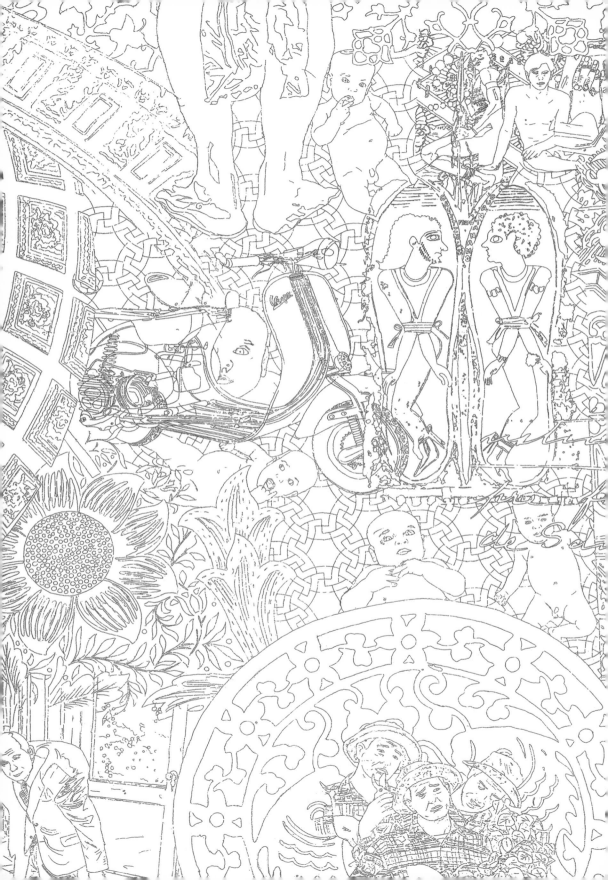

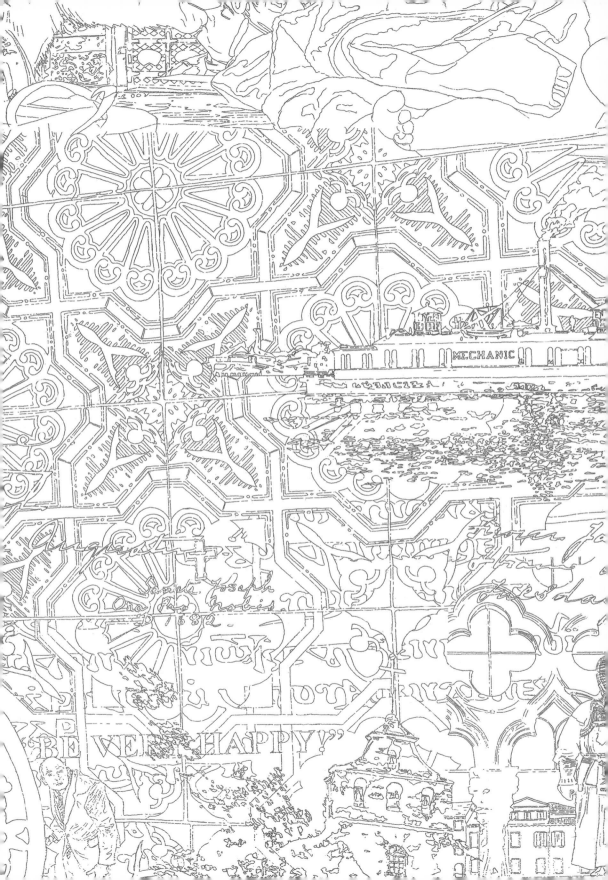

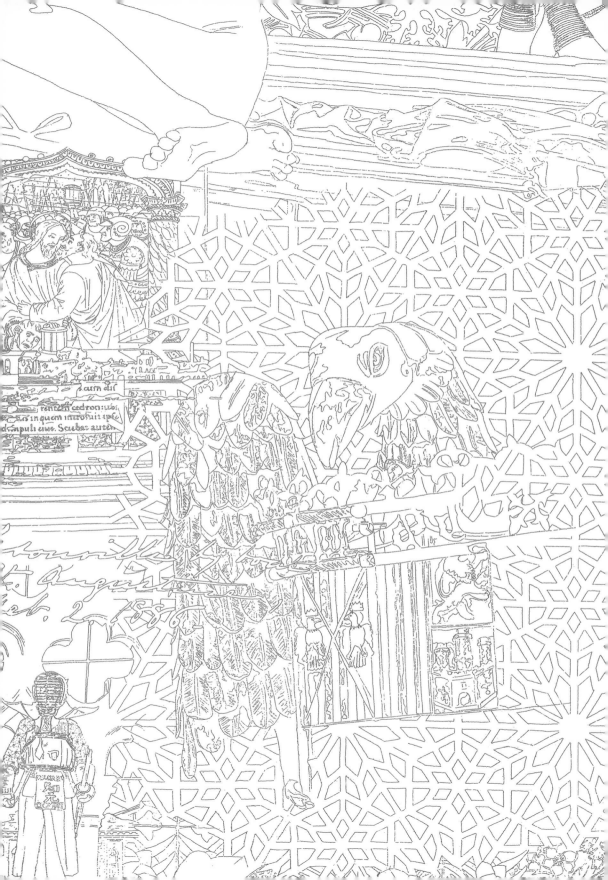

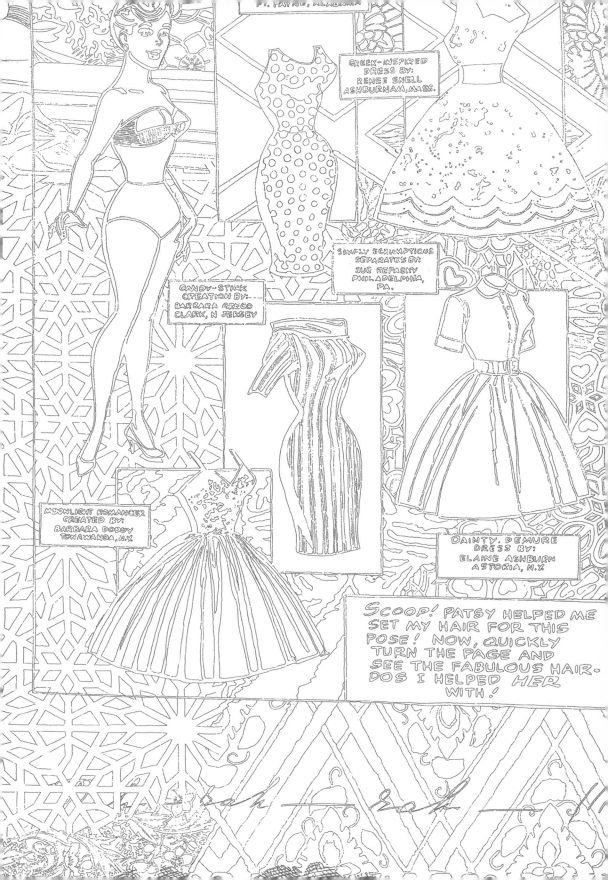

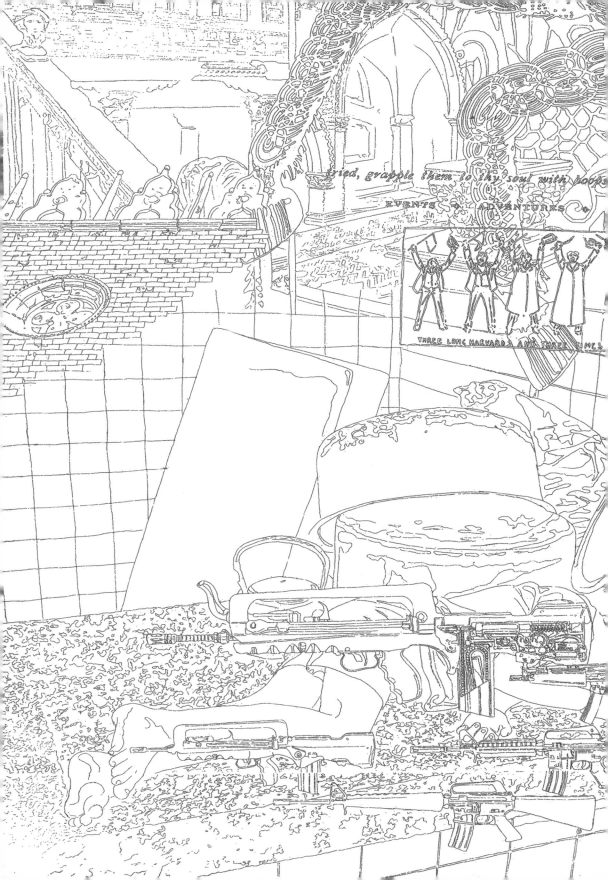

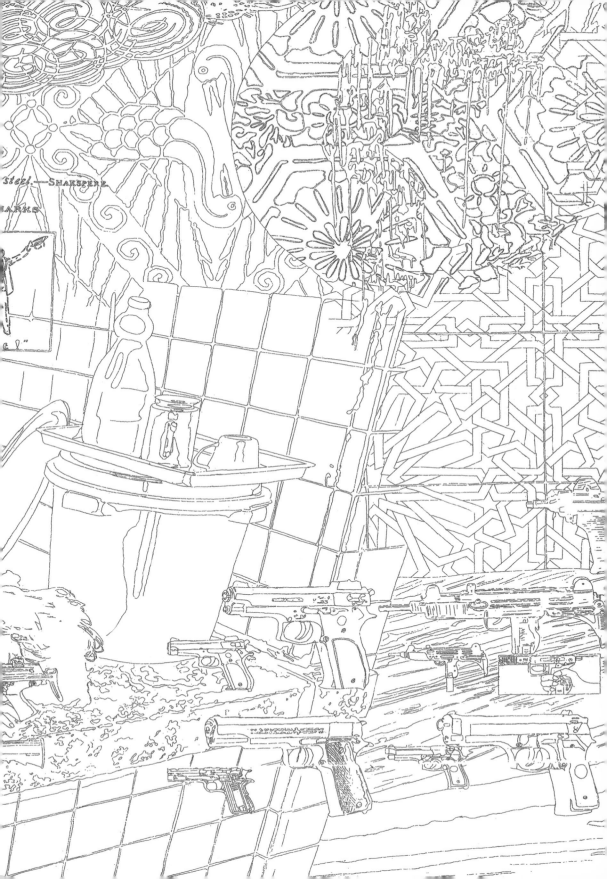

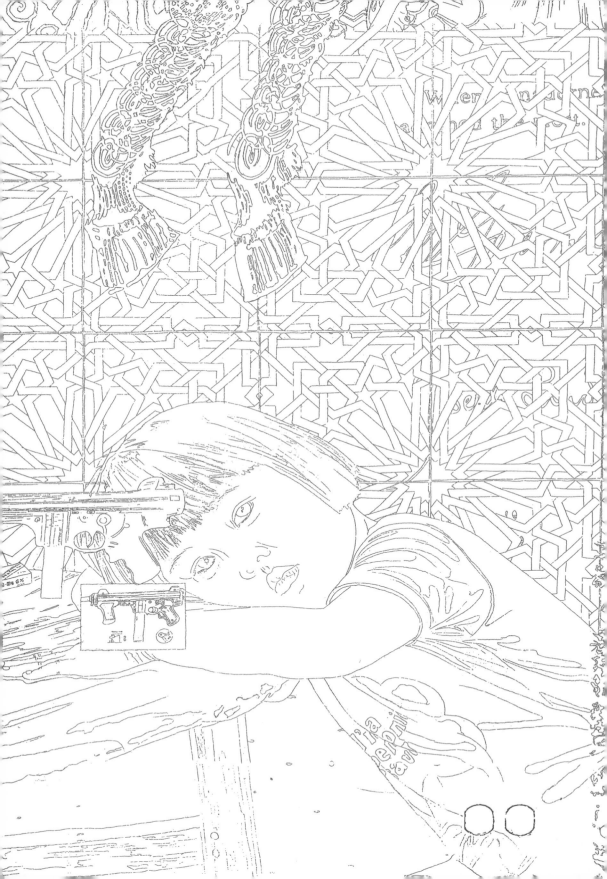

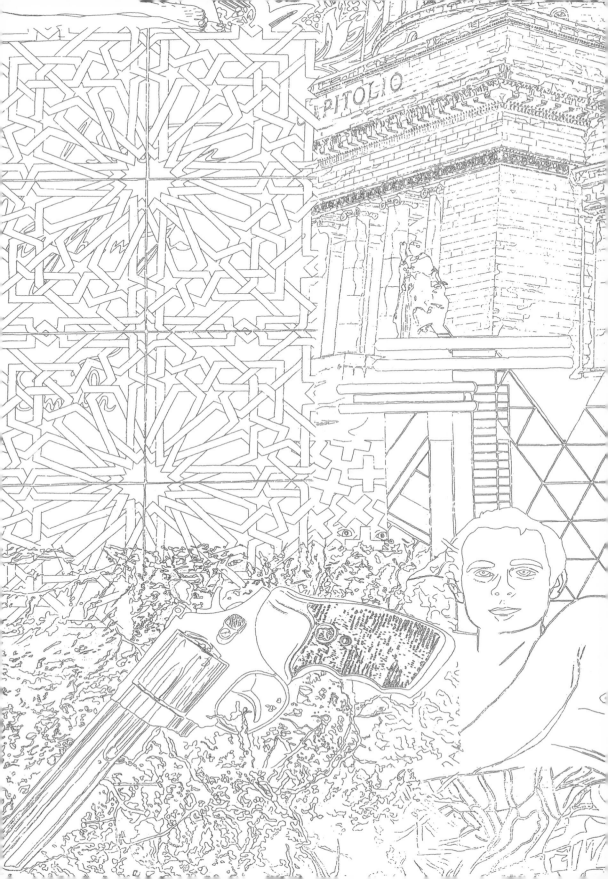

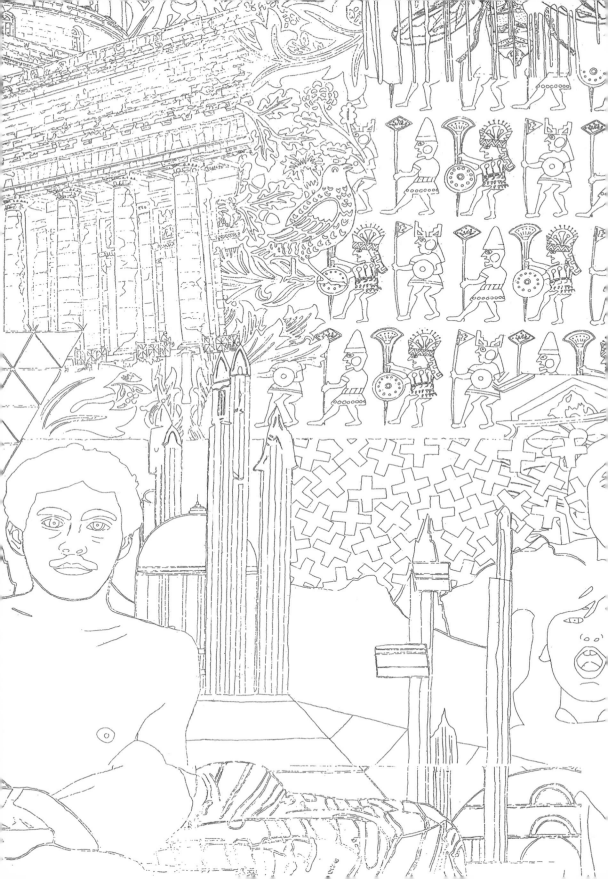

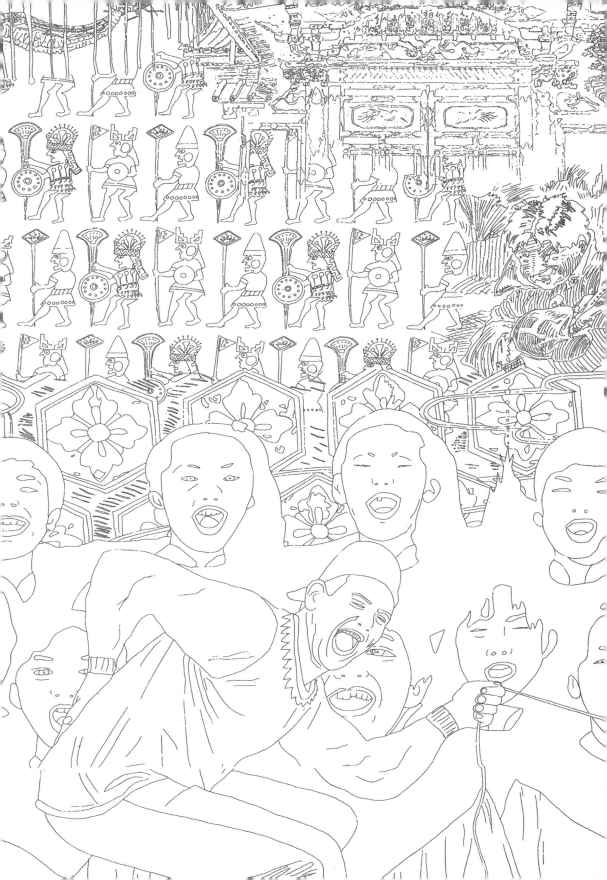

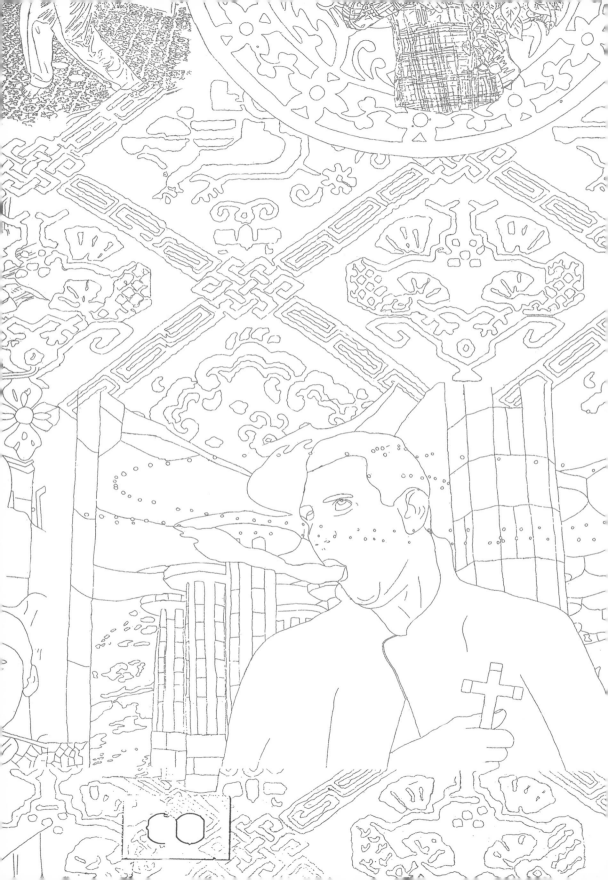

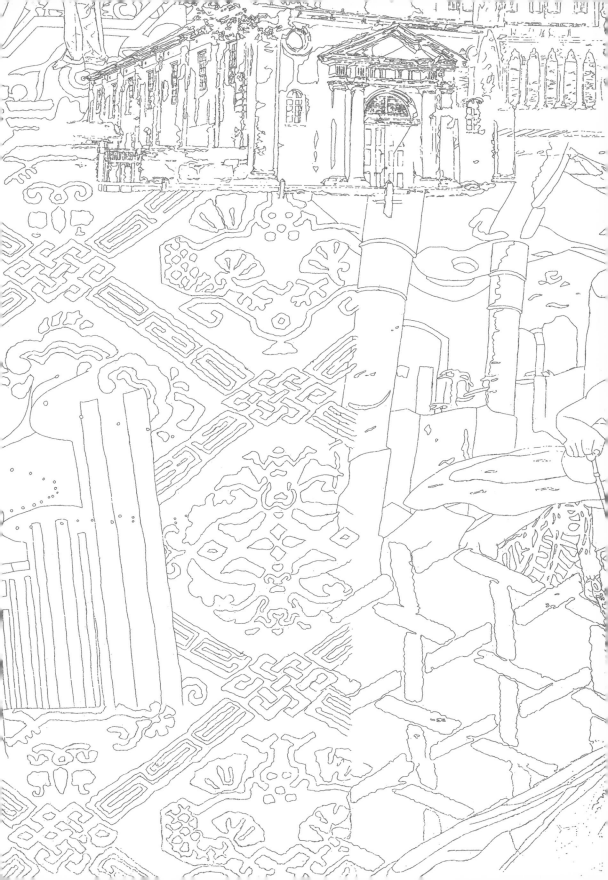

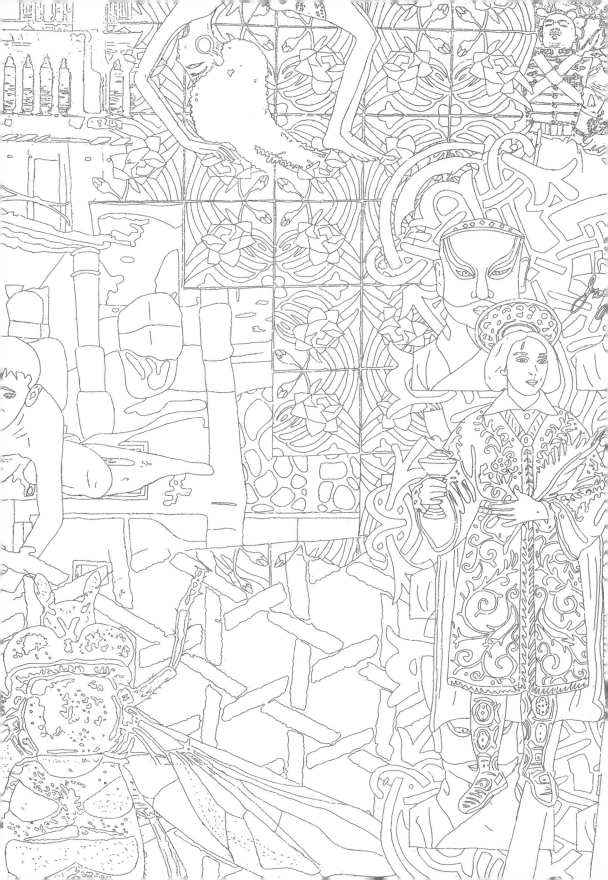

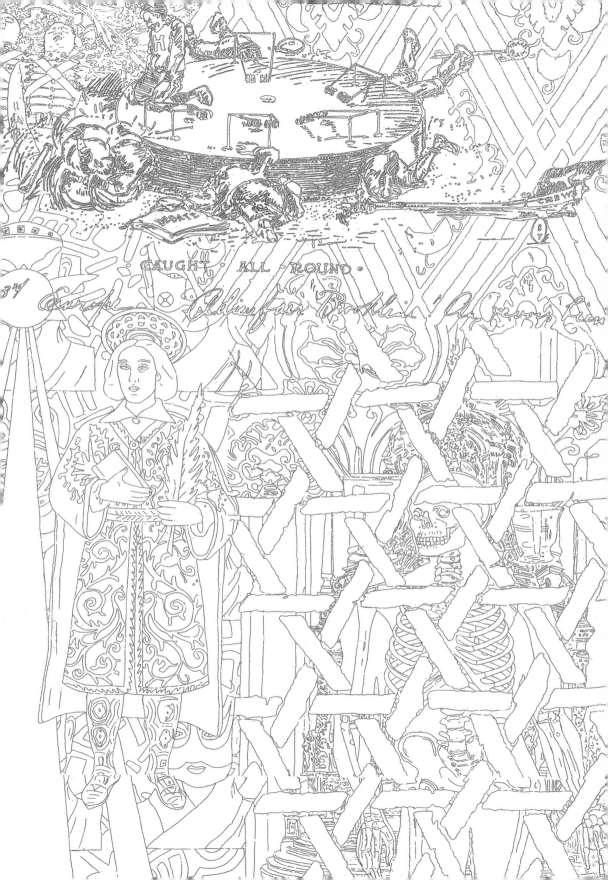

CAUGHT · ALL · ROUND ·

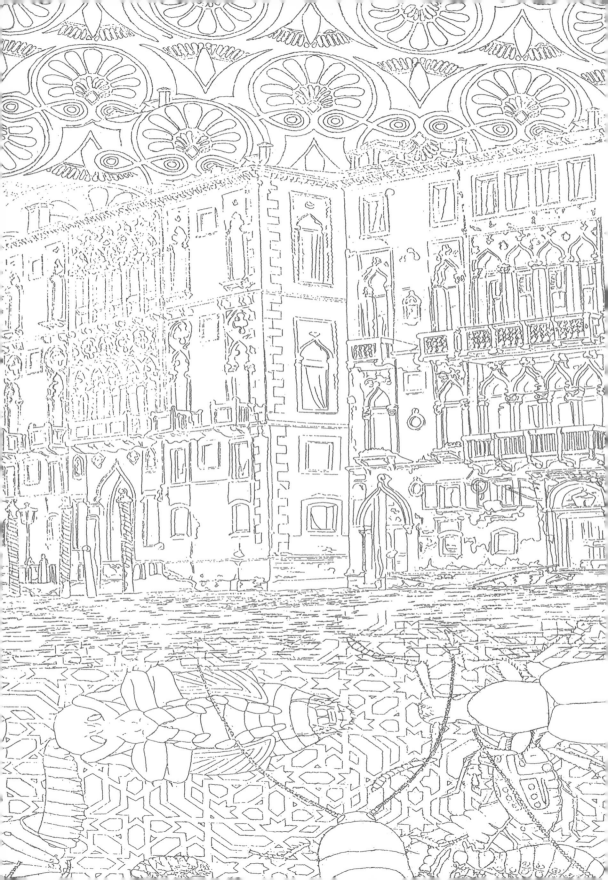

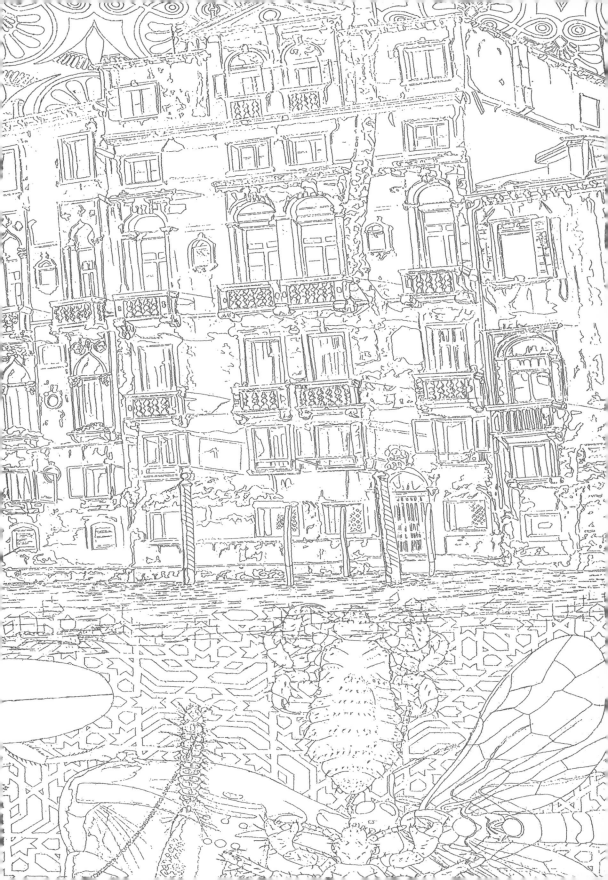

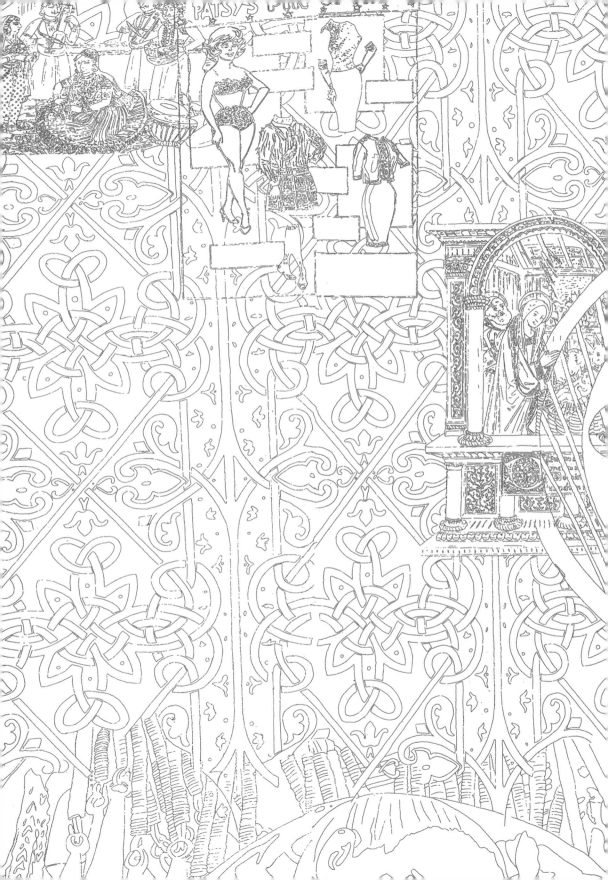

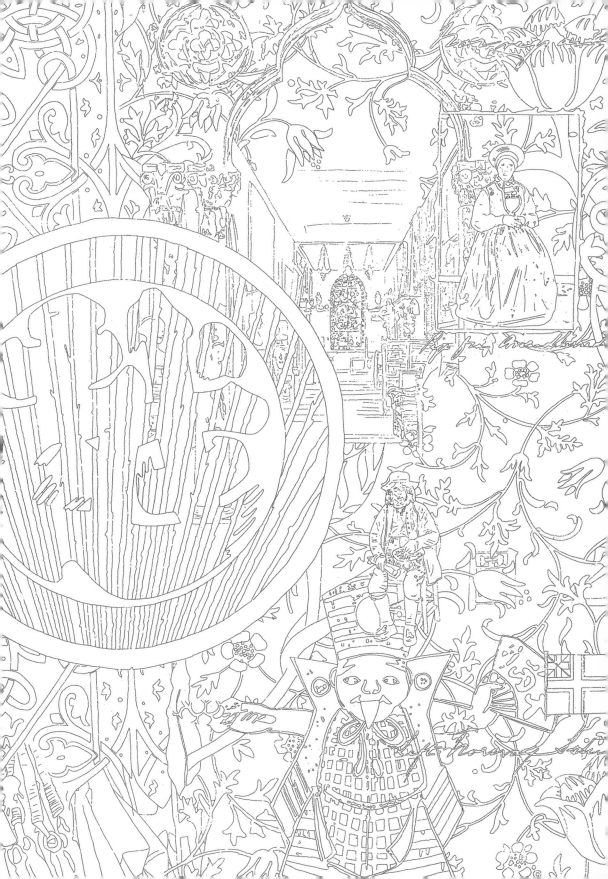

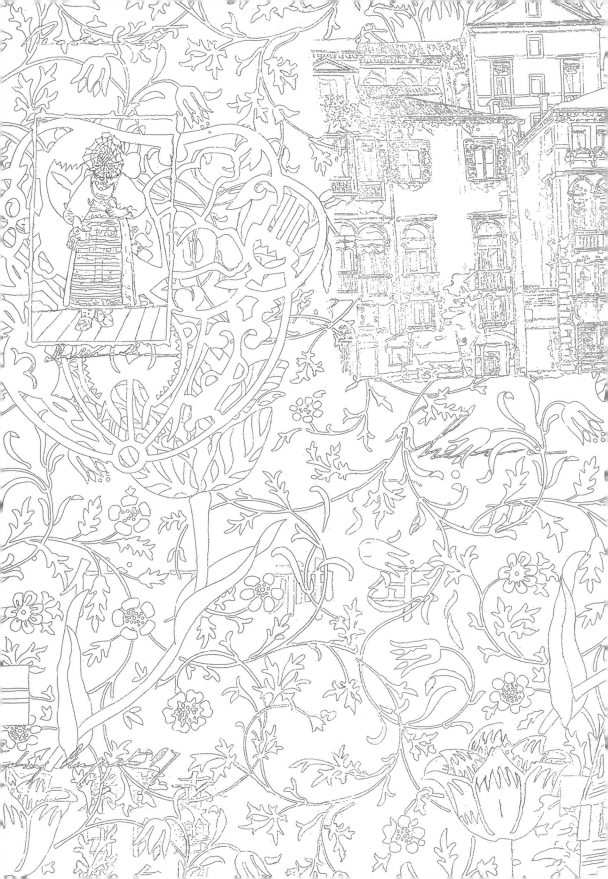

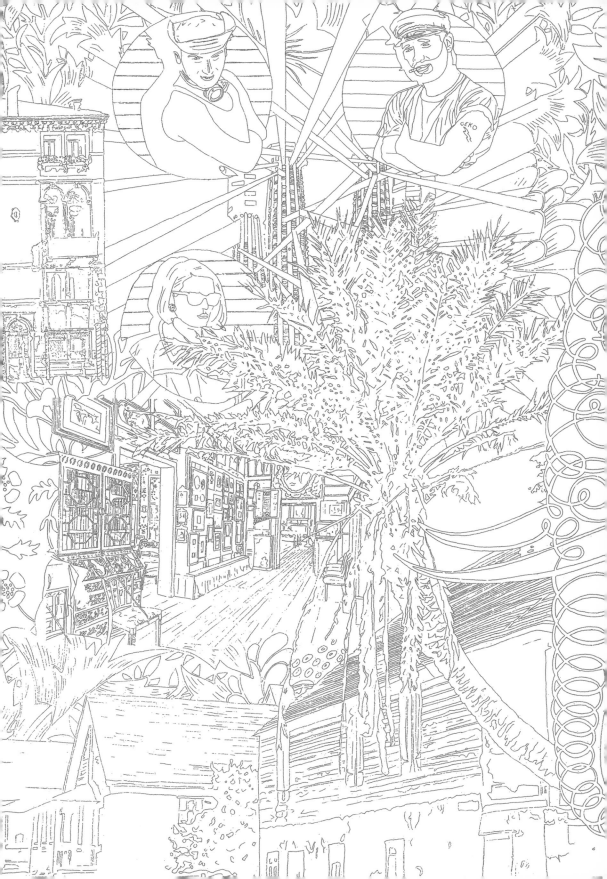

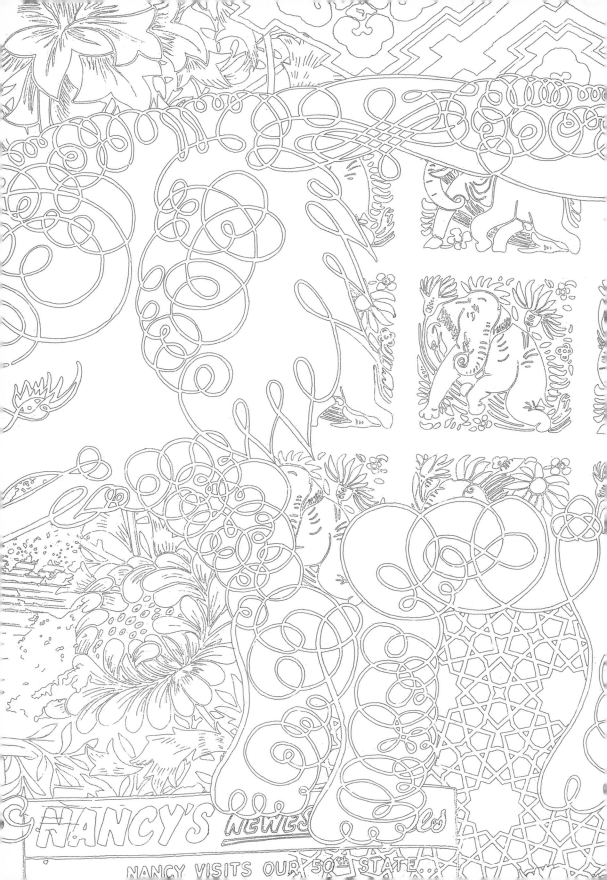

NANCY'S NEWEST

NANCY VISITS OUR 50th STATE...

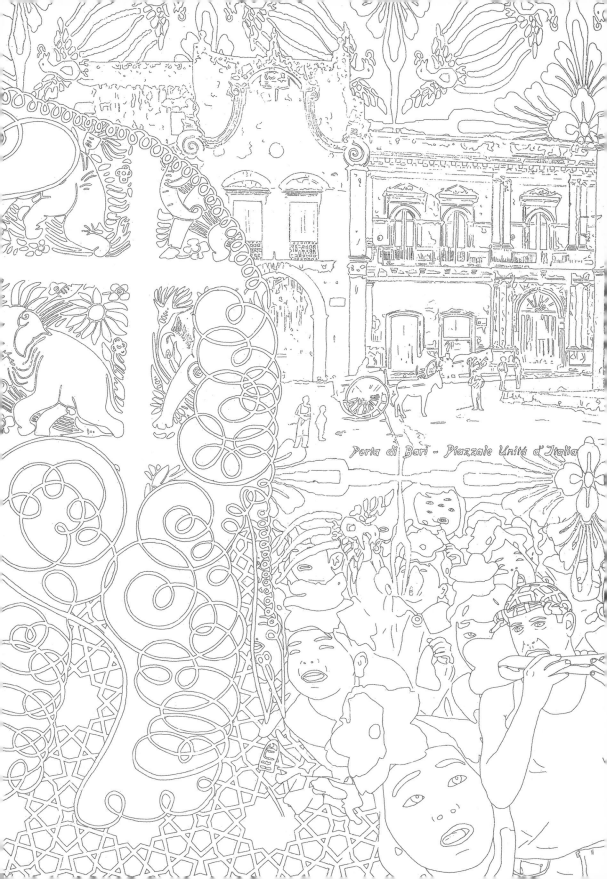

Porta di Bari - Piazzale Unità d'Italia

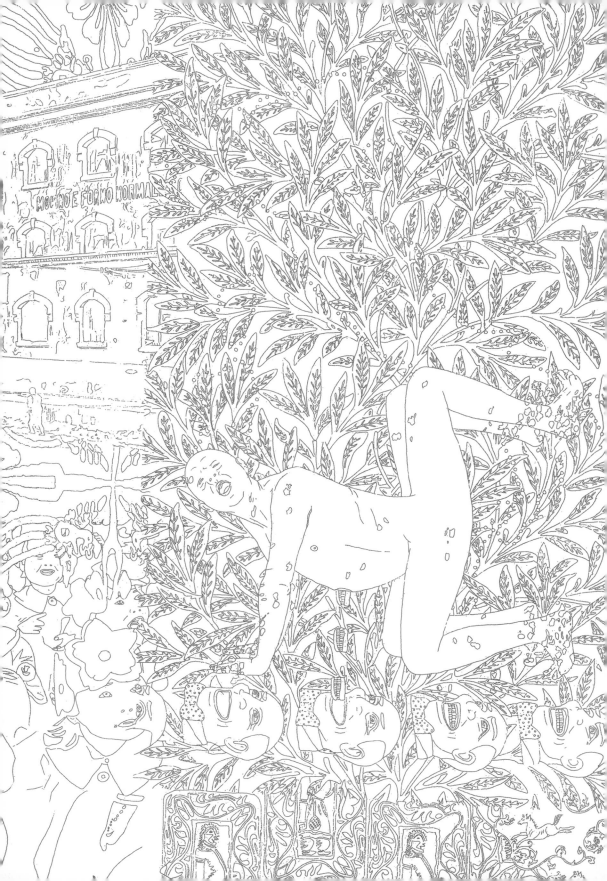

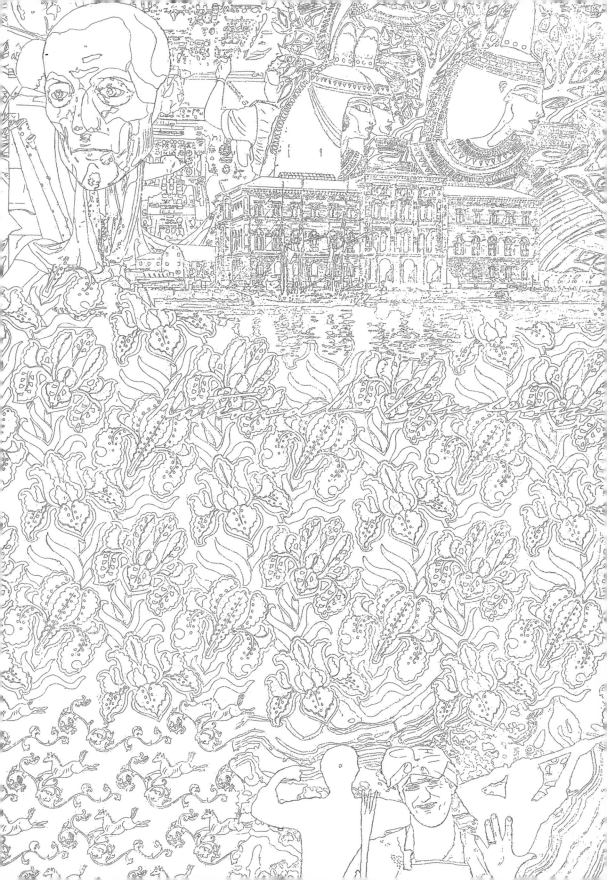

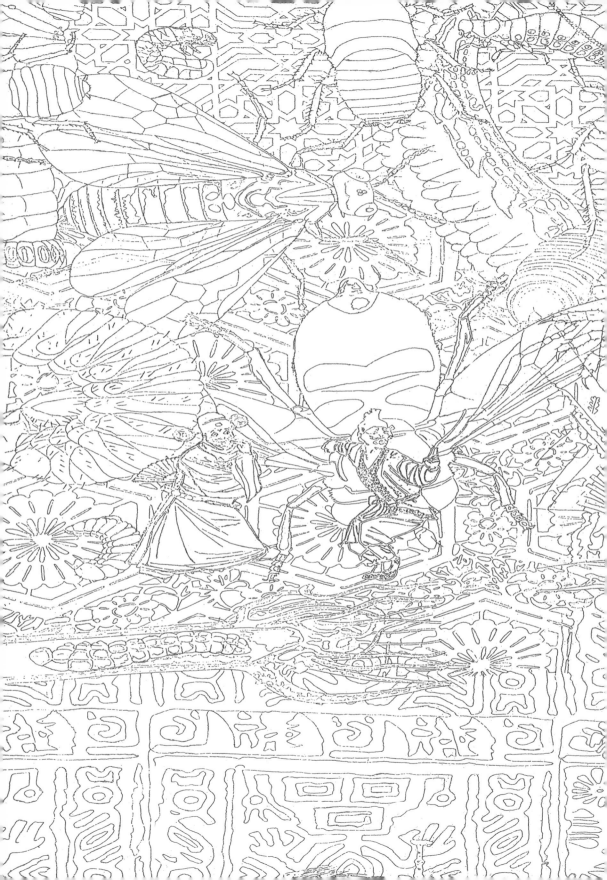

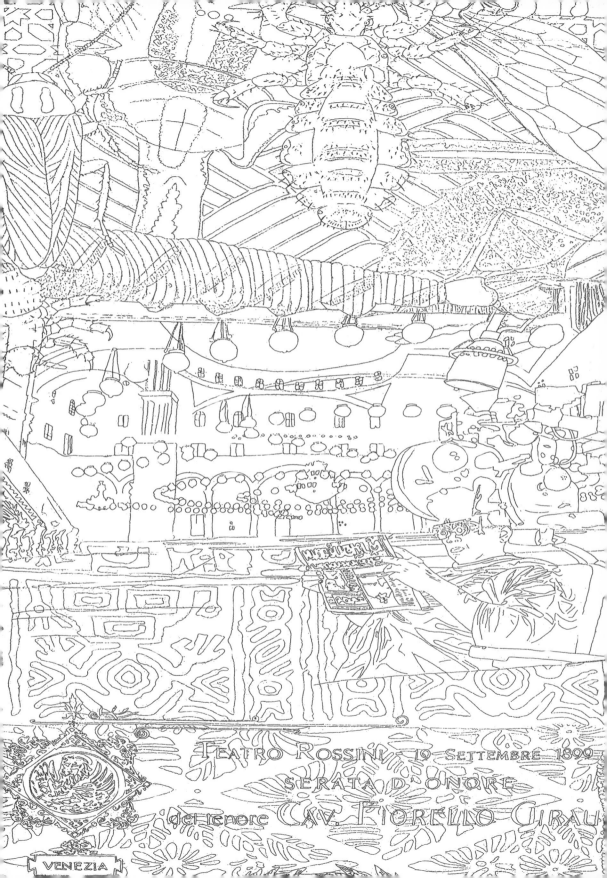

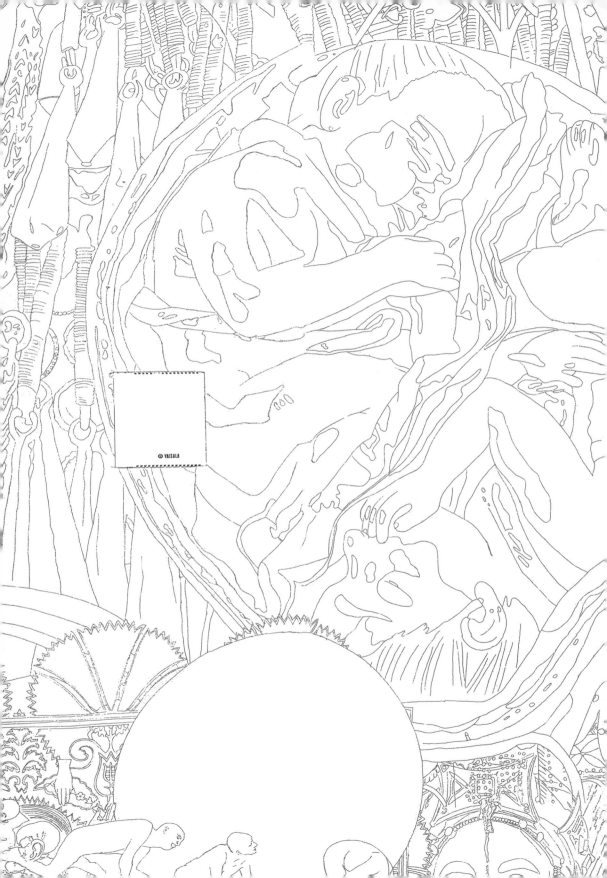

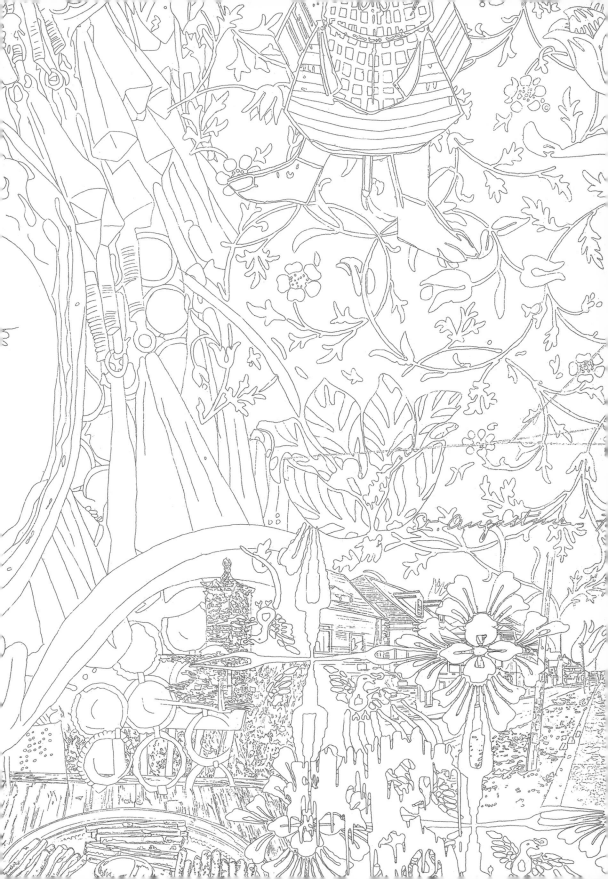

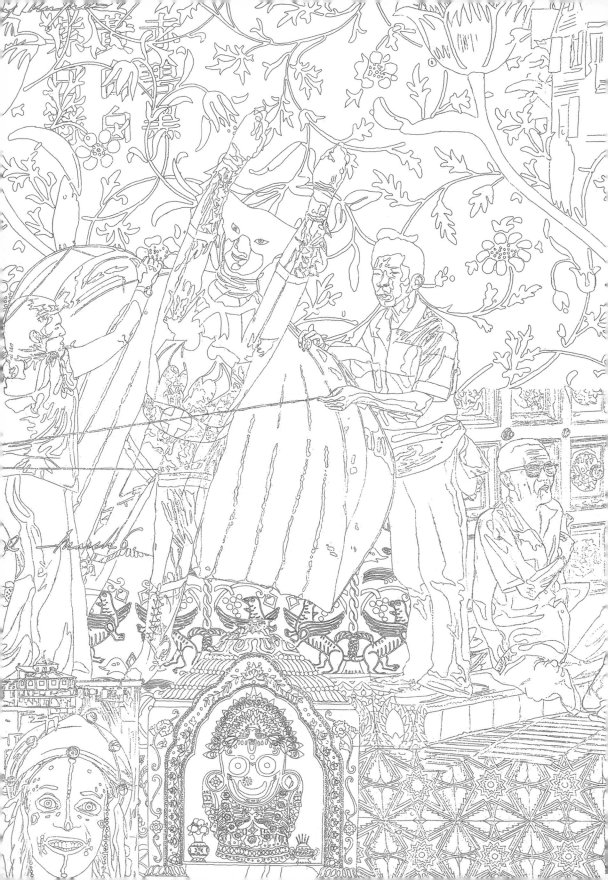

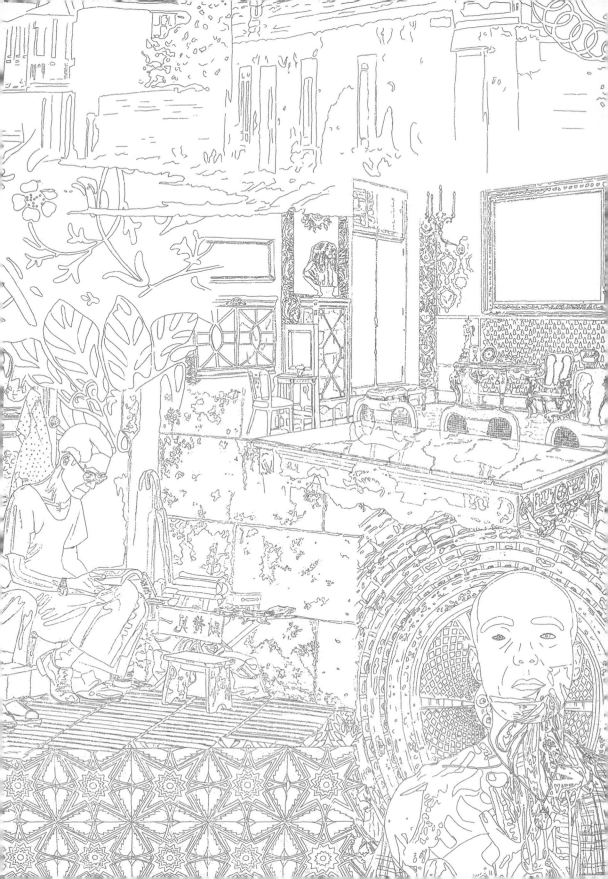

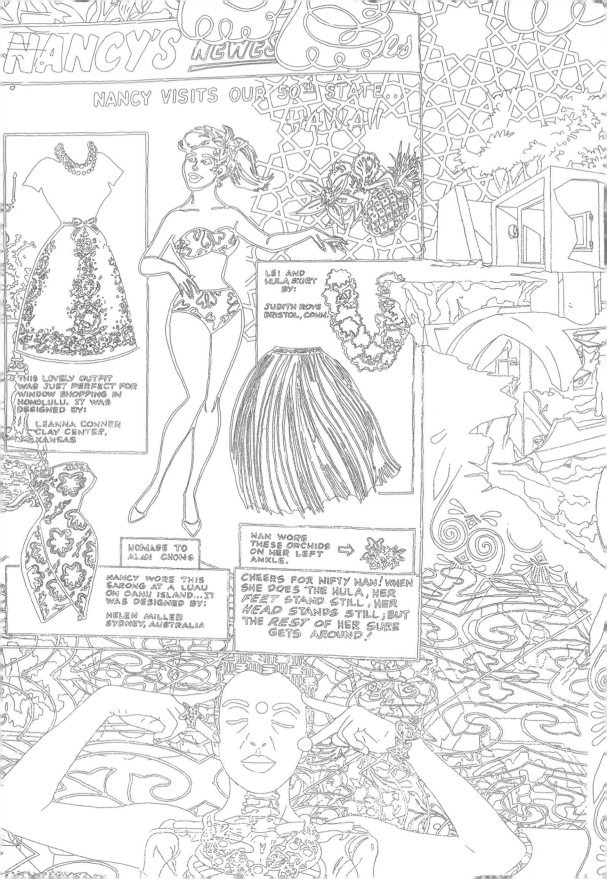

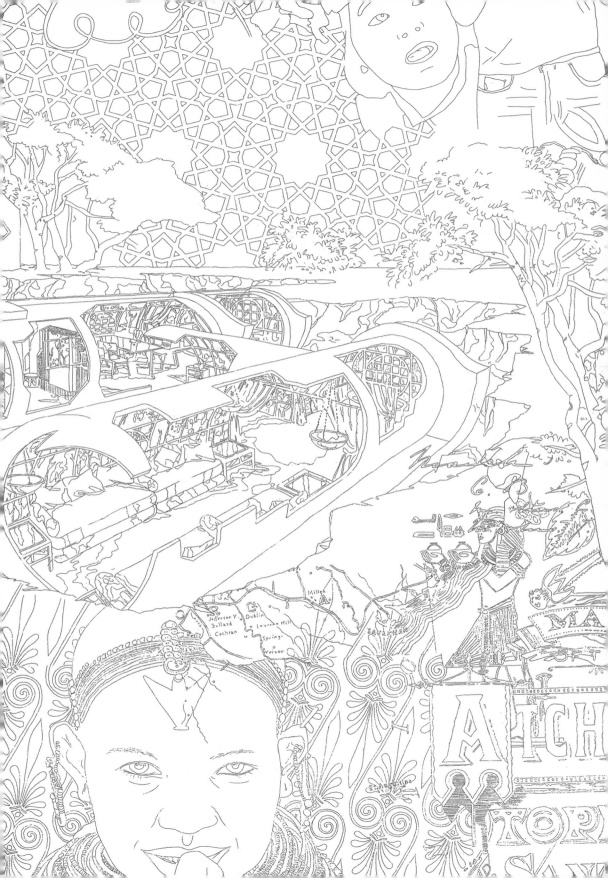

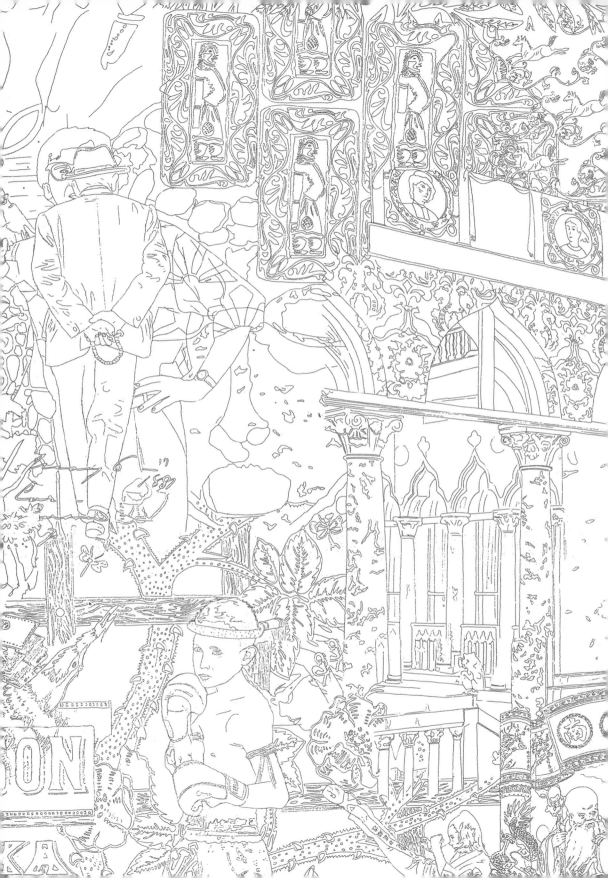

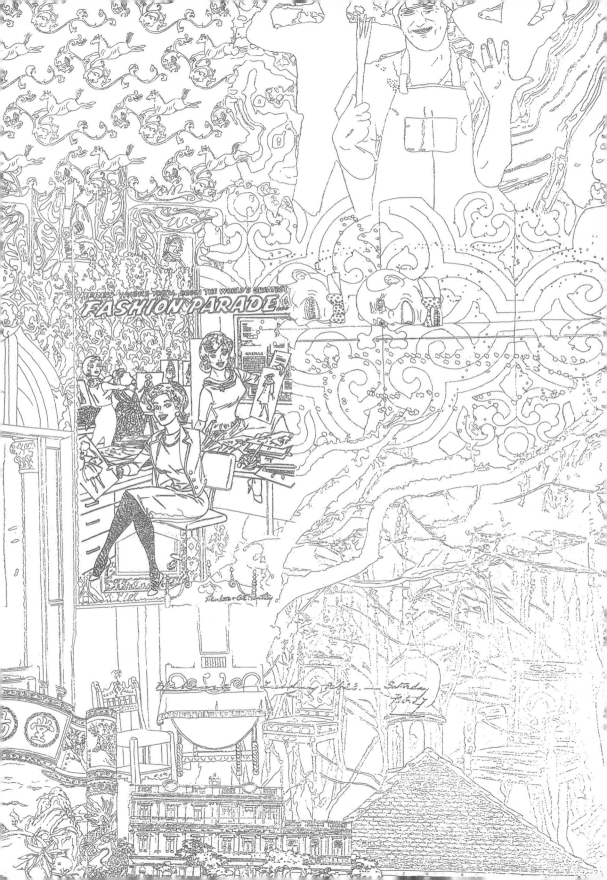

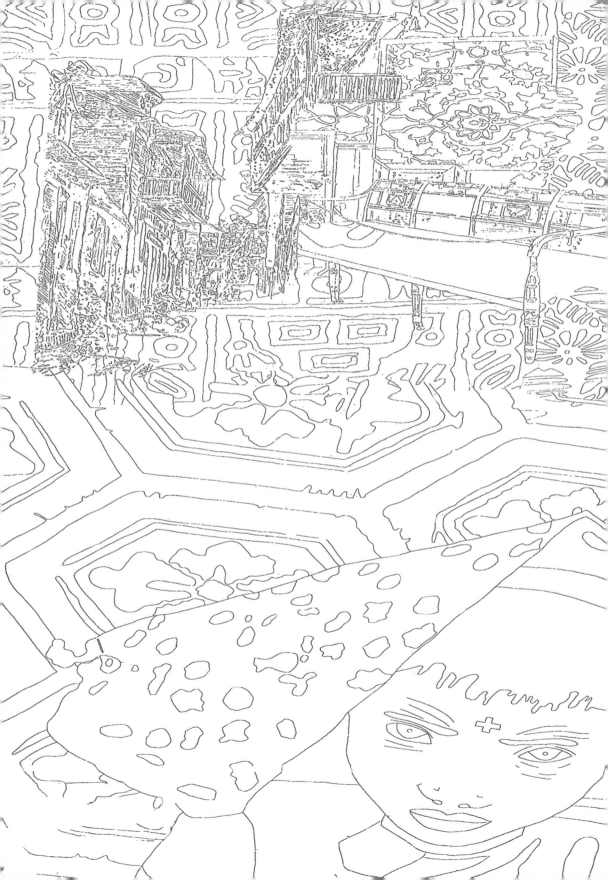

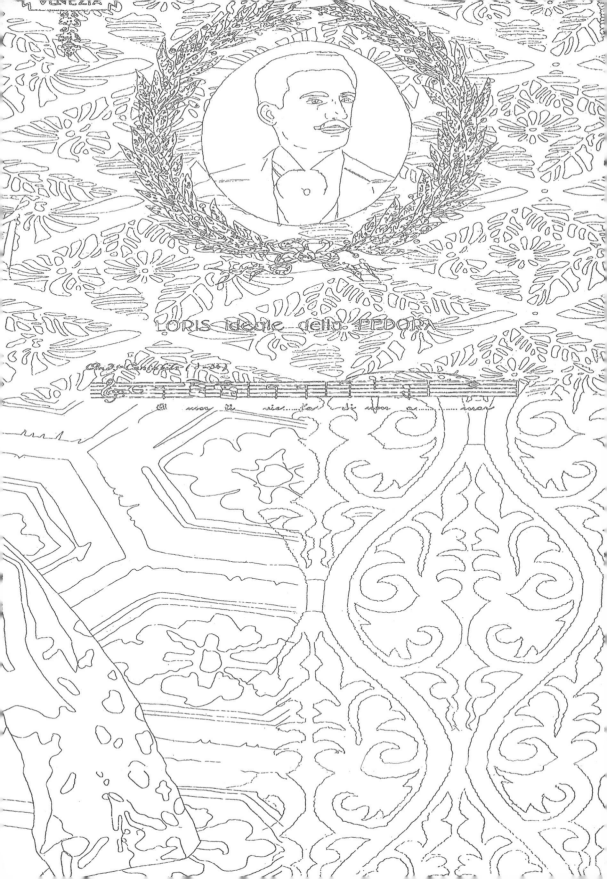

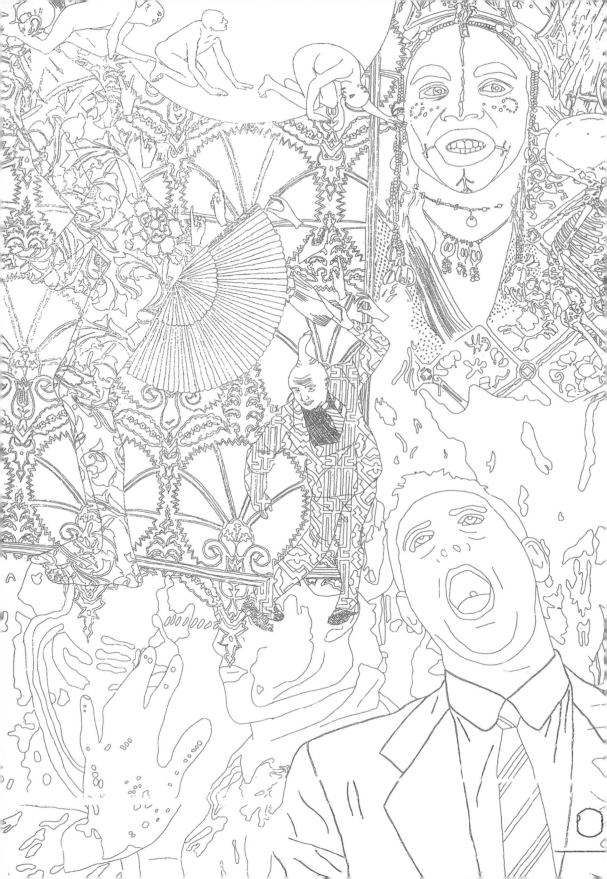

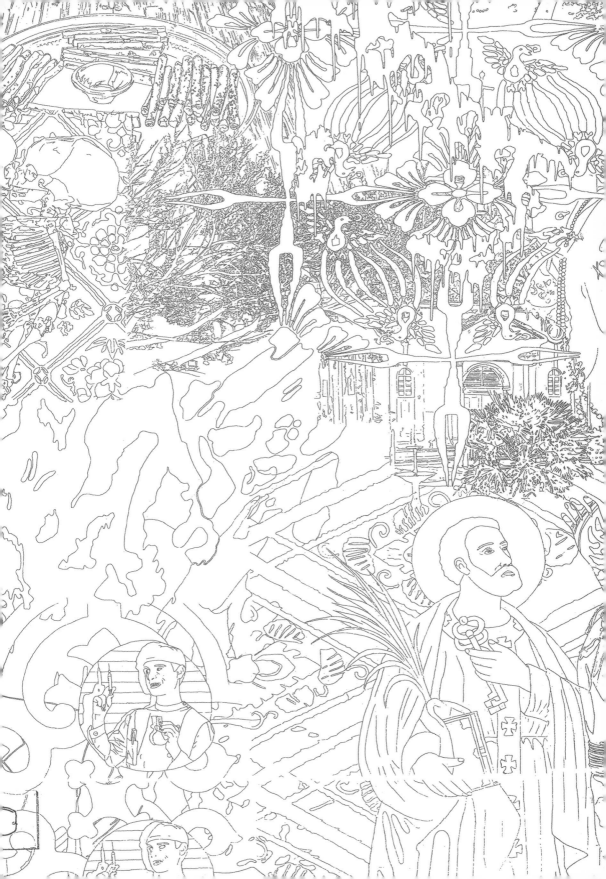

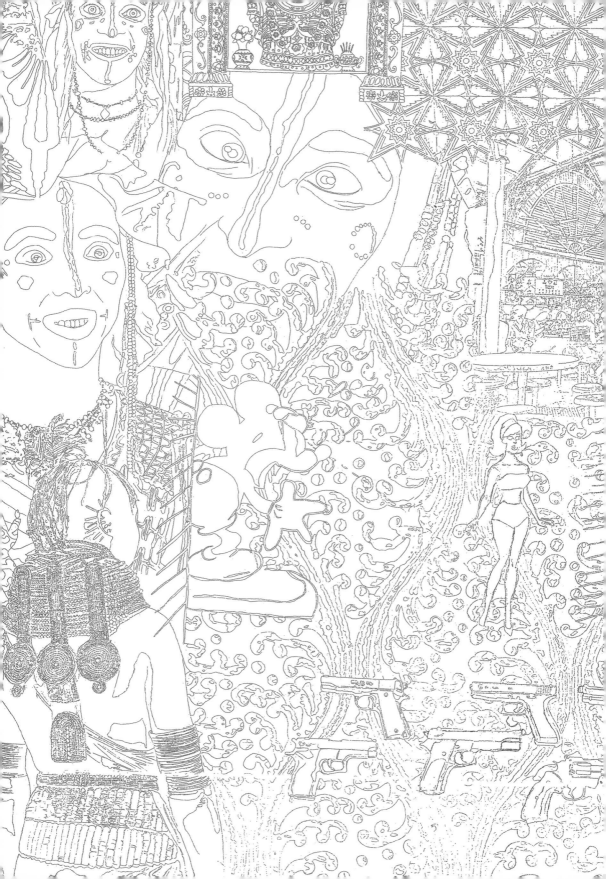

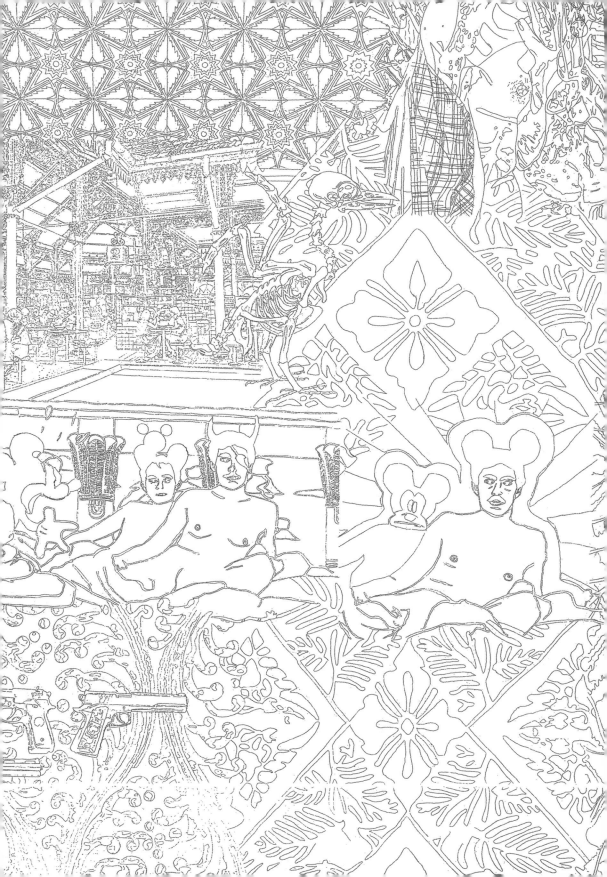

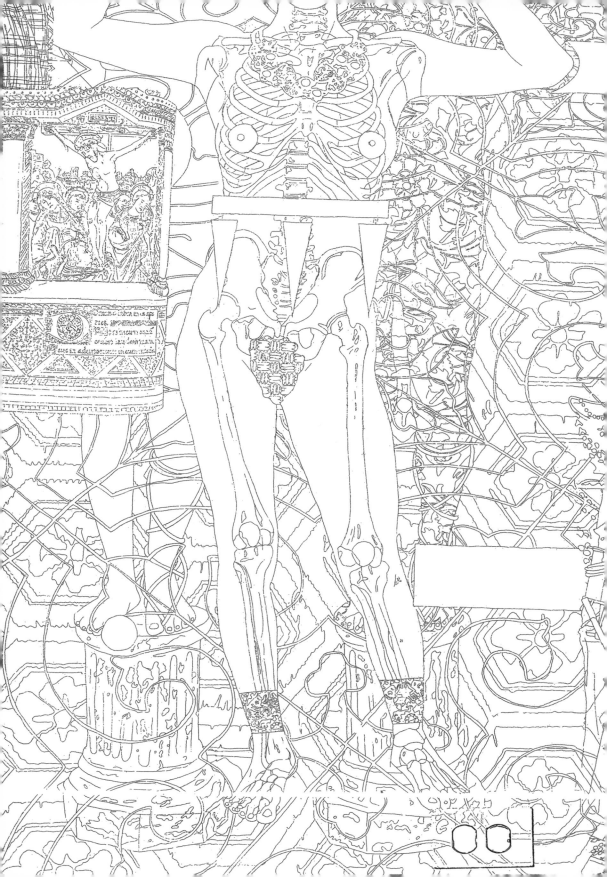

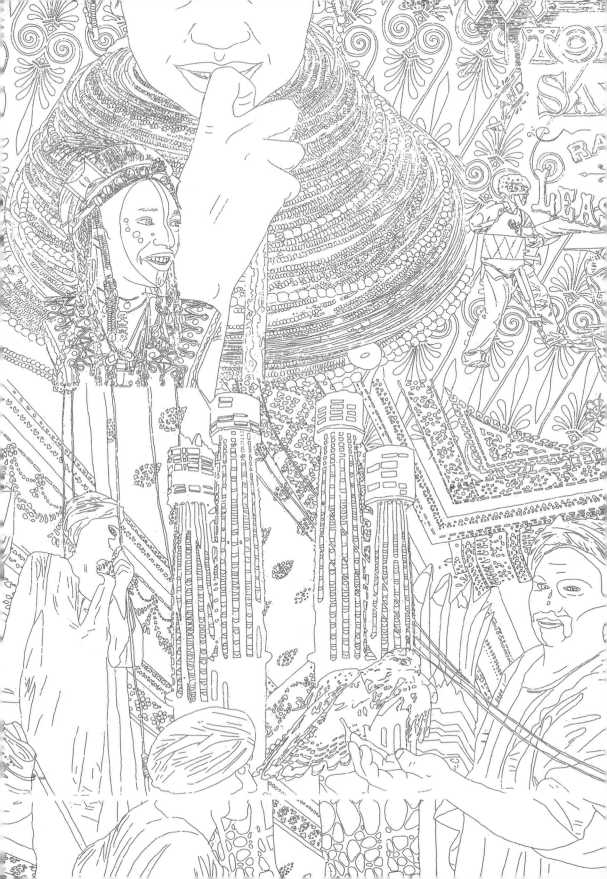

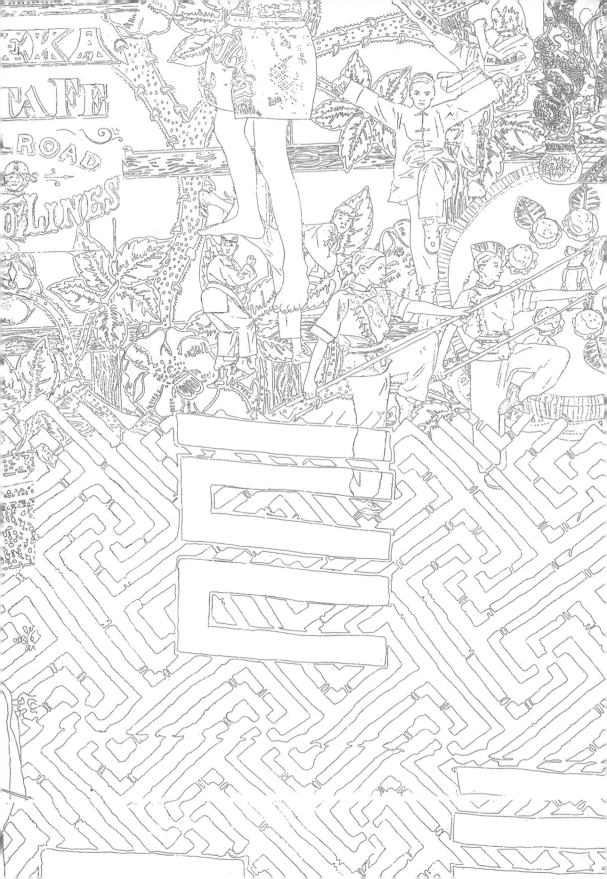

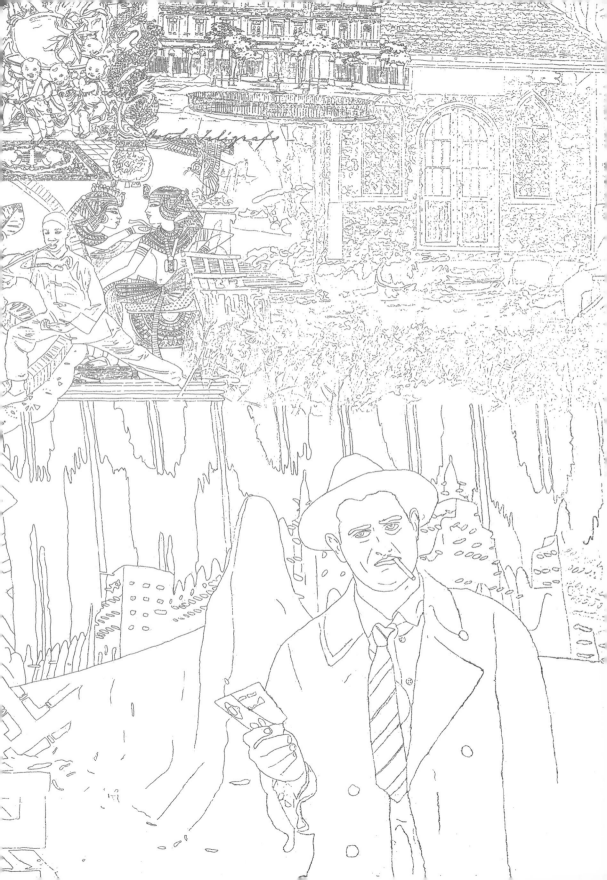

Appendix

Selected Exhibitions

Born in Naples in 1954, Maurizio Cannavacciuolo lives and works in Rome and Cortona (Arezzo)

Solo exhibitions

2004
Suzy Shammah, Milan

Isabella Stewart Gardner Museum, Boston

2003
Edicola Notte, Rome

Museo de Arte Contemporaneo, Santiago, Chile

Sprovieri, London

2002
Museu da Republica, Galeria Catete, Rio de Janeiro

Incontri Internazionali d'Arte, Palazzo Taverna, Rome

2001
Franco Noero, Turin

Francesca Kaufmann, Milan

2000
Cardi, Milan

1999
Asprey Jacques Contemporary Art Exhibitions, London

1998
Studio Guenzani, Milan

1000eventi, Milan

1997
Gian Enzo Sperone, Rome

Fundacion Ludwig de Cuba, La Habana

1996
Sperone Westwater, New York

Fabio Sargentini-L'Attico, Rome

1000eventi, Turin

1995
Palazzo delle Esposizioni,

Roof-garden, Rome

1993
Studio Guenzani, Milan

Gian Enzo Sperone, Rome

1990
Studio Scalise, Naples

1989
Museum Puri Lukisan, Ubud (Bali)

1983
Lucio Amelio, Naples

1979
Lucio Amelio, Naples

Group exhibitions

2004
"Maurizio Cannavacciuolo, Jorge Peris, Cristiano Pintaldi, Daniele Puppi," Sprovieri project space, London

"Rome collects. Arte contemporanea italiana nelle collezioni pubbliche e private," American Academy, Rome

"Nowhere Else but Here," Danielle Arnaud, London

"... So Fresh, So Cool!," Cardi & Co., Milan

"Ori d'artista," Museo del Corso, Rome

2003
"Luoghi d'affezione. Paesaggio-Passaggio," Hotel de Ville, Brussels

"Futuro italiano," European Parliament, Brussels

2002
"Scatole dell'Eros," Museo Archeologico Nazionale, Naples

"Le Opere e i Giorni," Certosa di San Lorenzo, Padula (Salerno)

"Dubuffet e l'arte dei graffiti," Palazzo Martinengo, Brescia

"Az égbolt tùlsò felén," Mùcsarnok, Budapest

2001
"Odissee dell'Arte," Museo Revoltella, Trieste

"L'altra metà del cielo," Galleria d'Arte Moderna, Bologna

"El cuerpo del arte," I Bienal de Valencia, Convento del Carmen, Valencia

"A misura d'io," Cardi & Co., Milan

"Senza Mani! Provos e biciclette bianche," Antonio Colombo, Milan

2000
"L'altra metà del cielo," Rupertinum, Salzburg/Kunstammlungen, Chemnitz

"Arte in Giro 2000," Ex mattatoio, Rome

"Futurama," Museo Pecci, Prato

"Da Warhol al 2000, Gian Enzo Sperone 35 anni di mostre fra Europa e America," Palazzo Cavour, Turin

"Images. Italian Art from 1942 to the present," European Central Bank, Frankfurt

"Oltre 20 oggetti da indossare," ELP Studio, Rome

1999
"Sarajevo 2000," Muzei Savremene Umjetnosti, Sarajevo

"Disidentico. Maschile femminile e oltre," Maschio Angioino, Naples

"Gioielli," Internos, Milan

"Libri d'Artista in Italia," Galleria

Civica d'Arte Moderna e Contemporanea, Turin

"Eventi multimediali," Galleria Nazionale d'Arte Moderna, Rome

"Arte italiana in apnea multimediale," Salara, Bologna

1998
"Coquito con mortadella," Istituto Superior de Arte, La Habana

"Panta. Sedici più uno racconti per immagini," Carlomaria Weber, Turin

"Mitovelocità," Galleria d'Arte Moderna e Contemporanea, Repubblica di San Marino

"Disidentico. Maschile femminile e oltre," Palazzo Branciforte, Palermo

"Sarajevo 2000," Museum moderner Kunst Stiftung Ludwig, Vienna

"Gioielli," ELP Studio, Rome

"Lepisma saccharina," Magazzino d'Arte Moderna, Rome

1997
"Arte e riciclaggio al mattatoio," Ex mattatoio, Rome

"Il Toro nell'arte," Santo Ficara, Florence

"Il Giro d'Italia dell'arte: Napoli," Fabio Sargentini-L'Attico, Rome

"Le projet et l'essence. Aspects de la peinture italienne des années '90," Musée Sursock, Beyrouth/ National Library, Damascus

"Luoghi," Galleria d'Arte Moderna e Contemporanea, Repubblica di San Marino

"Via Crucis," Sala de Exposiciones, Universidad de Cantabria, Santander

"Collezione permanente," Galleria Civica di Arte Contemporanea, Siracusa

"Arte Italiana. Ultimi quarant'anni. Pittura iconica," Galleria d'Arte Moderna, Bologna

1996
"Controfigura," Studio Guenzani, Milan

"Leda e il cigno," Alberto Weber, Turin

"Caleidoscopio," Ruggerini & Zonca, Milan

"Small scale," Joseph Helman, New York

1995
"Estetica del delitto," Sergio Tossi, Prato

"Yet yet yet," Bianca Pilat, Milan

"Figure," Patrizia Buonanno Arte Contemporanea, Mezzolombardo (Trento)

"1st international biennal of water colour," Obcina Kamnik, Kamnik (Slovenija)

"Fax art," Palazzo delle Esposizioni, Roof-garden, Rome

"Nutrimenti dell'arte," Ex Convento di San Carlo, Erice (Trapani)

"Untitled," Alberto Valerio, Brescia

"Persone," Confini, Cuneo

"Il fantastico nella giovane arte italiana," Accademia delle arti visive, Siracusa

1994
"Uomini di mondo," Confini, Cuneo

"Via Crucis," Alberto Weber, Turin

"Cyberintimismo," Erotica, Fiera Campionaria, Bologna

"Artisti per Opening," Accademia Britannica, Rome

"Aspetti dell'erotismo nella giovane arte italiana," A.C.C. Gebaude, Kolonia

"Tutti questi mondi," Carini, Prato

1993
"La costanza della ragione," Paolo Majorana, Brescia

"Pittura mediale," Ruggerini & Zonca, Milan

"Noir, bloody noir," Planita, Rome

"Iconografie mediali," Fortezza da Basso, Florence

"Time to time," Castello di Rivara, Rivara (Turin)

"Disincanti," La Nuova Pesa, Rome

"Officine Napoletane," Villa Letizia, Barra (Naples)

"La montagna dipinta," Castel Telvana, Civezzano (Trento)/Studio Raffaello, Trento

"The spirit of drawing," Sperone Westwater, New York

"Il grande disegno italiano," Guido Carbone, Turin

"I love you more than my own death," Slittamenti, XLV Biennale di Venezia, Venice

"Thàlatta, thàlatta!," Galleria Civica, Termoli (Campobasso)

"Art & Fashion: divagazioni su un cappotto," Massimo De Carlo, Milan

"La linea dell'immagine," Antico Chiostro di S. Antonio, Ceppaloni (Benevento)/Piano Nobile, Perugia

"A prescindere," Ex Opificio Gaslini, Pescara

"Palle," Stefania Miscetti, Rome

"Via Crucis," Cescà Galerie Musaion, Prague

1992
"Pittura mediale," Guido Carbone, Turin

"Cannavacciuolo, Kirchhoff, Montesano, Zalopany," Studio Scalise, Naples

"Medialismi," Villa d'Este, Tivoli (Rome)

"Paesaggio con rovine," Orestiadi di Gibellina, Gibellina (Trapani)

"Miramare," Paolo Tonin, Turin

"A parete," Galleria Ennio Borzi, Rome

"Figure della geometria. L'ordine ironico: nuove icone, nuovi riti, nuovi miti," A.A.M., Rome

"Vietato ai minori," Studio Bocchi, Rome

1991
"Dadapolis," Sala 1, Rome

"Media Ikos," Studio Cristofori, Bologna

"Pittura mediale," Forum arte contemporanea, Rome

1989
"Portraits," Mantra-Paolo Tonin, Turin

1985
"Vent'anni," Lucio Amelio, Naples

1983
"XVIII Internationale Malerwochen in der Steiermark," Palais Attems, Graz

1982
"Avanguardia-Transavanguardia," spazio giovani, Mura Aureliane, Rome

"Incursioni oltre le linee,"

XVI rassegna internazionale d'arte di Acireale, Acireale/Museo Civico, Ortona

"Conseguenze impreviste: Arte, Moda, Design," Centro Storico, Prato

1981
"Vokacije slikarstva," Galerija studentskog, Kulturnog centra, Belgrade

"Aljofre barroco," Palazzo Ducezio, Noto (Siracusa)

1980
"8," Lucio Amelio, Naples/Marilena Bonomo, Bari

"7 juin 1980," Centre d'Art Contemporain, Genève

"Perspective 80," Art 11'80, Internationale Kunstmesse, Basel

1978
"Villa Colletta," Arienzo (Caserta)

Design
Gabriele Nason
with Daniela Meda

Editorial Coordination
Emanuela Belloni

Editing
Charles Gute
Diana C. Stoll

Copywriting and Press Office
Silvia Palombi Arte&Mostre, Milan

*Web Design and Online
Promotion*
Barbara Bonacina

Cover and endpapers
Details of *TV Dinner* wall drawing
by Maurizio Cannavacciuolo

Photo Credits
Stewart Clements, William
Howcroft/Isabella Stewart Gardner
Museum

other photographs
Mimmo Capone
Sheldan C. Collins
Maurizio Elia
Matthew Hollow
Mario La Porta
Paolo Vandrasch

© 2005
Edizioni Charta, Milan

© Isabella Stewart Gardner Museum

images © Maurizio Cannavacciuolo

texts © the authors

exhibition photographs © 2005
Stewart Clements, William
Howcroft/Isabella Stewart Gardner
Museum

All Rights Reserved

ISBN 88-8158-480-8
Printed in Italy

Edizioni Charta
Via della Moscova 27
20121 Milano
ph. +39-026598098/026598200
fax +39-026598577
e-mail: edcharta@tin.it
www.chartaartbooks.it

Isabella Stewart Gardner Museum
2 Palace Road
Boston, Massachusetts 02115
www.gardnermuseum.org
e-mail: contemporary@isgm.org

To find out more about Charta,
and to learn about our most
recent publications, visit
www.chartaartbooks.it

Printed in January 2005
by Tipografia Rumor S.r.l., Vicenza
for Edizioni Charta